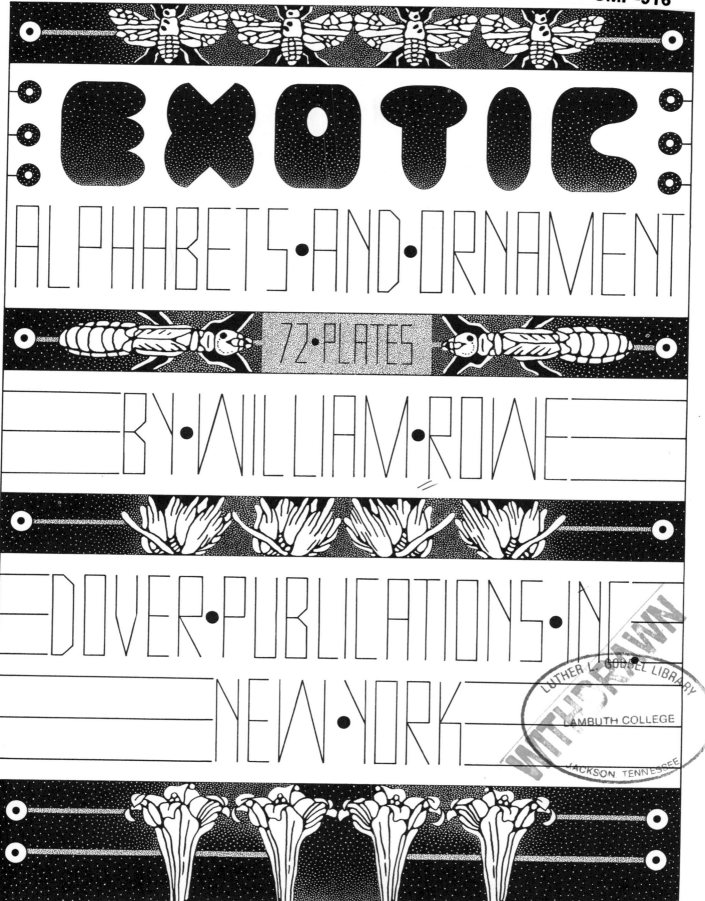

EXOTIC
ALPHABETS·AND·ORNAMENT
72·PLATES
BY·WILLIAM·ROWE
DOVER·PUBLICATIONS·INC·
NEW·YORK

Published in Canada by General Publishing Company, Ltd., 30 Lesmill Road, Don Mills, Toronto, Ontario.
Published in the United Kingdom by Constable and Company, Ltd., 10 Orange Street, London WC 2.

Exotic Alphabets and Ornament by William Rowe is a new work, first published by Dover Publications, Inc., in 1974.

DOVER *Pictorial Archive* SERIES

Exotic Alphabets and Ornament belongs to the Dover Pictorial Archive Series. Up to ten illustrations from this book may be reproduced on any one project or in any single publication free and without special permission. Wherever possible, please include a credit line indicating the title of this book, author and publisher. Please address the publisher for permission to make more extensive use of illustrations in this book than that authorized above.
The reproduction of this book in whole is prohibited.

International Standard Book Number: 0-486-22989-0
Library of Congress Catalog Card Number: 73-93544

Manufactured in the United States of America
Dover Publications, Inc.
180 Varick Street
New York, N.Y. 10014

PUBLISHER'S NOTE

An innovative young practitioner of the Art Deco style, creator of the 'Original Art Deco Designs' already published by Dover, here presents an entirely new volume of alphabets and ornament in which natural forms predominate.

The first part of the book contains eighteen complete alphabets of different sizes and moods, all highly ornate and displayed in imaginative ways—as scrambling bugs, in groups of three-letter and four-letter words, as butterflies with the A and the Z taking wing, and so on. There are letters built around lilies, palm trees, zinnias. One of the alphabets consists of huge letters, appearing one per page, which break down into numerous decorative borders and vignettes. There are also six sets of numerals.

The second part of the book includes a wealth of ornament. Richly detailed abstract and geometric Art Deco borders surround exciting images derived from nature: birds, shells, tropical fish, many species of insects, and plant life, including flowers, mushrooms and berries.

It is hoped that designers and decorators in all areas will find suggestions and ideas in this timely collection.

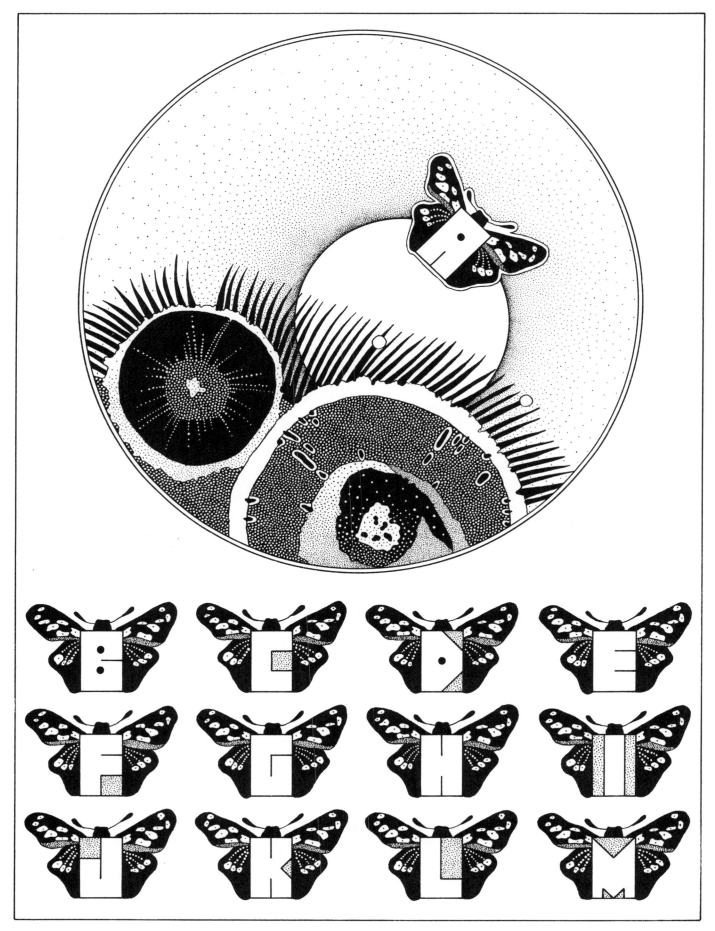

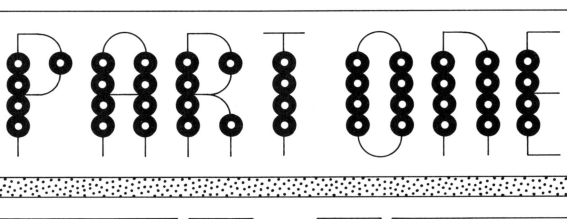

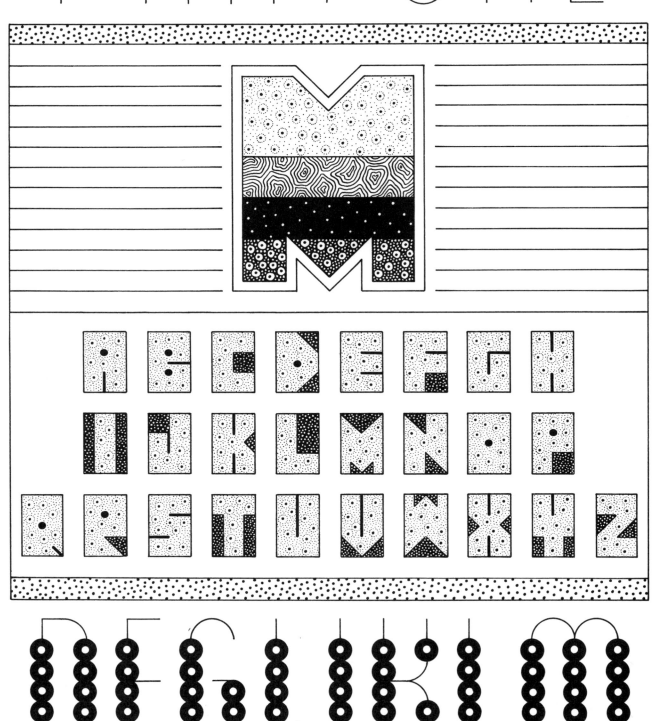

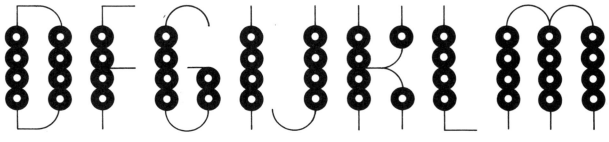

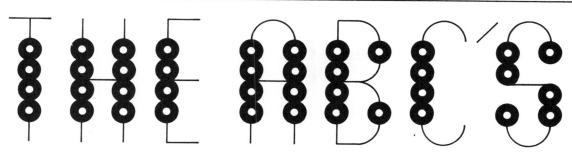

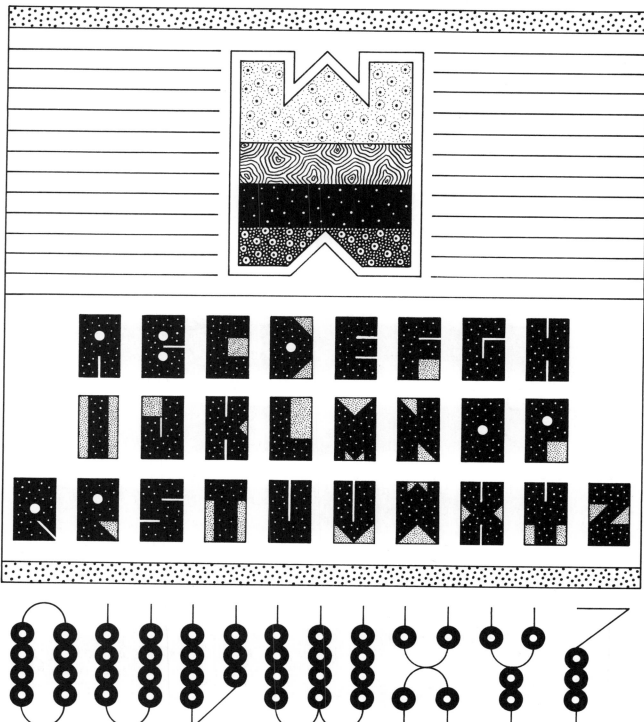

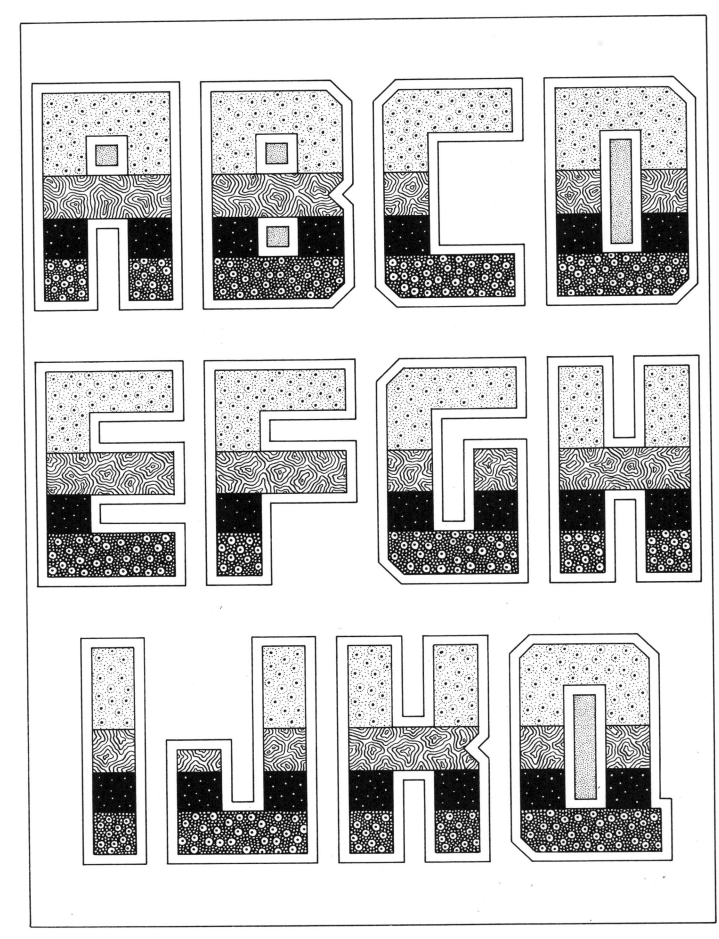

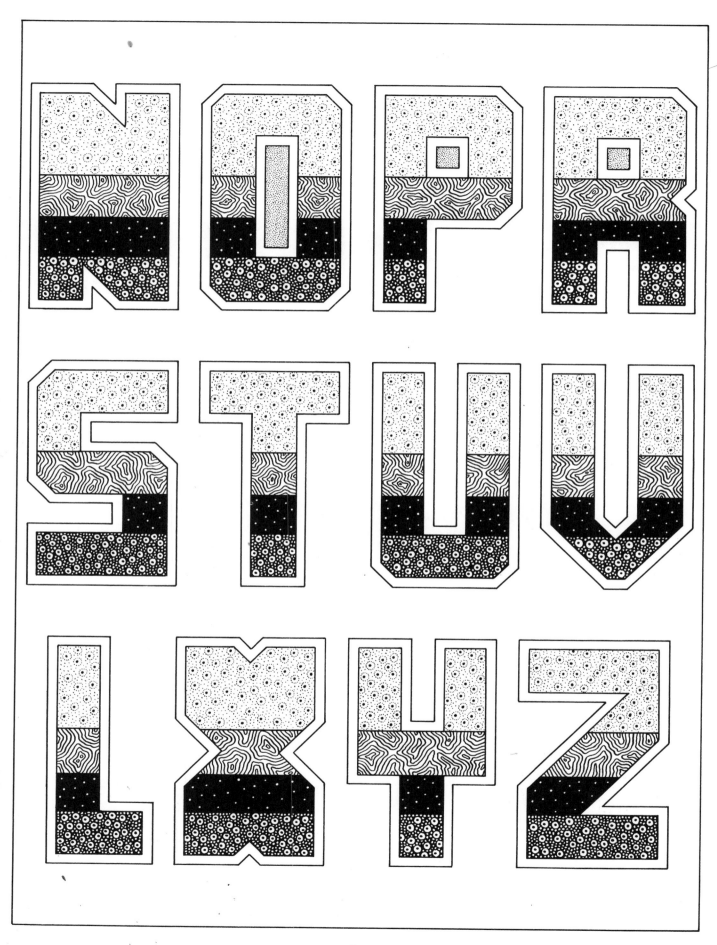

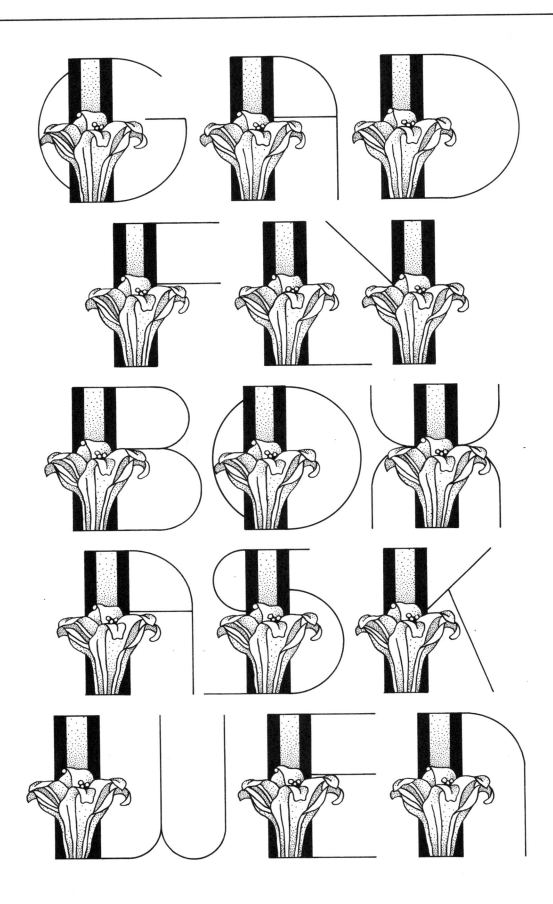

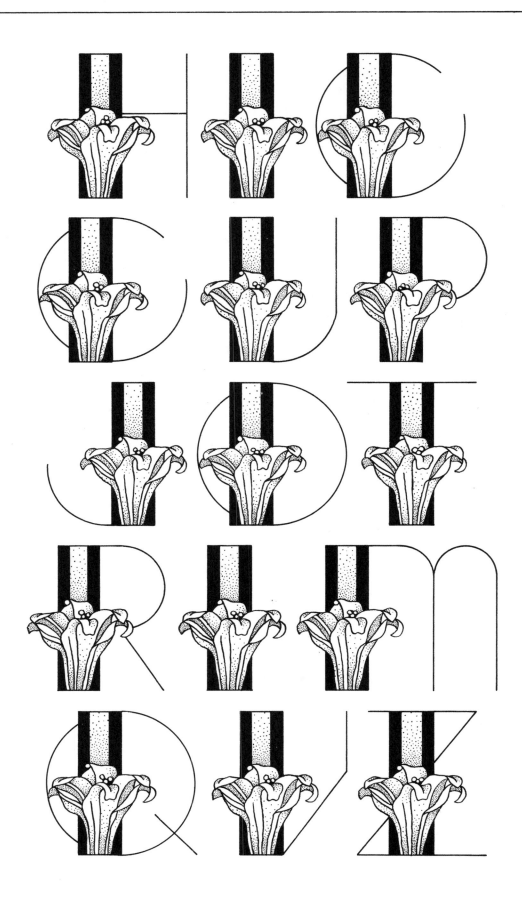

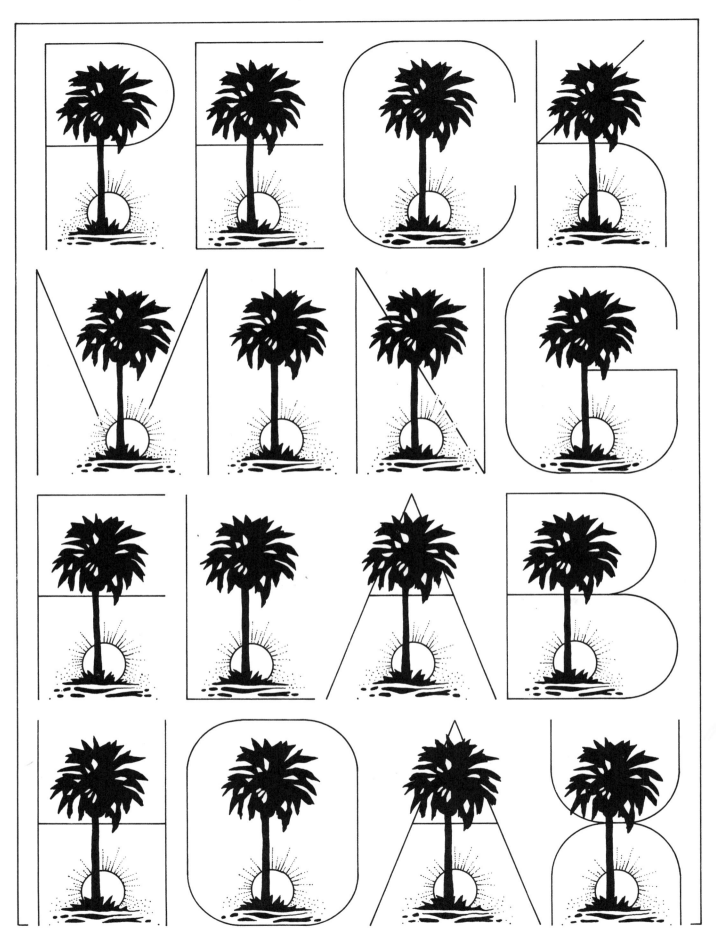

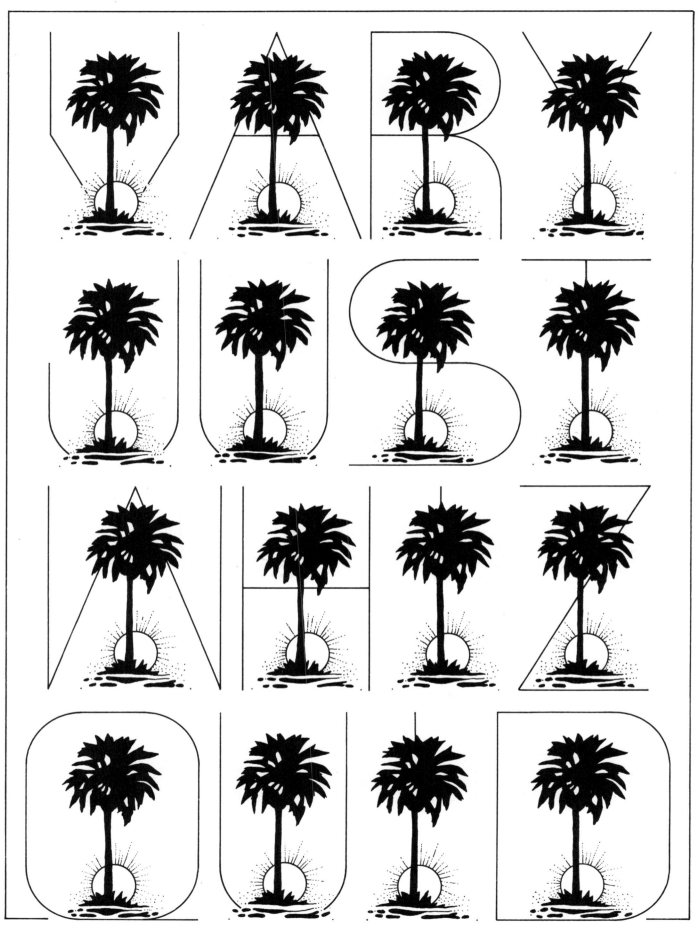

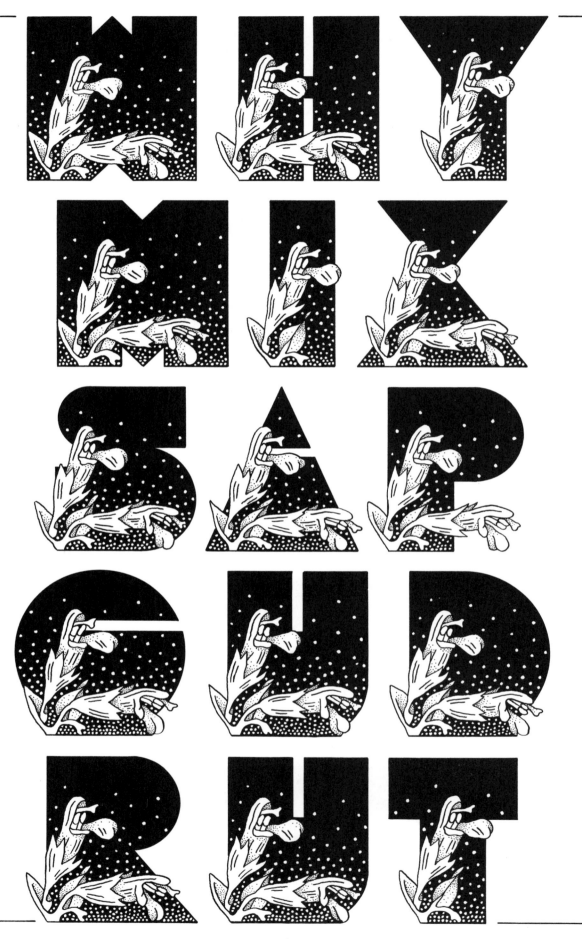

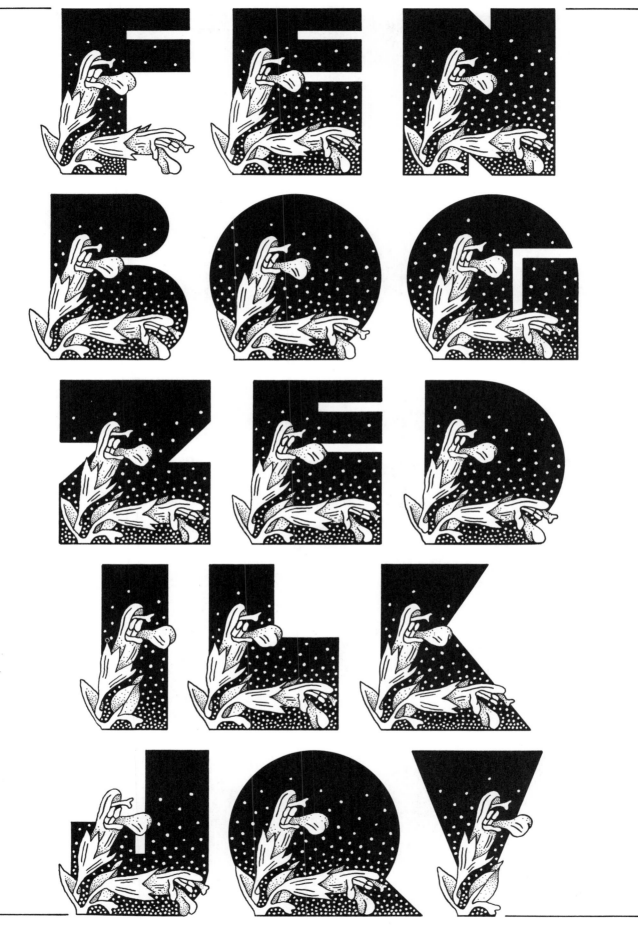

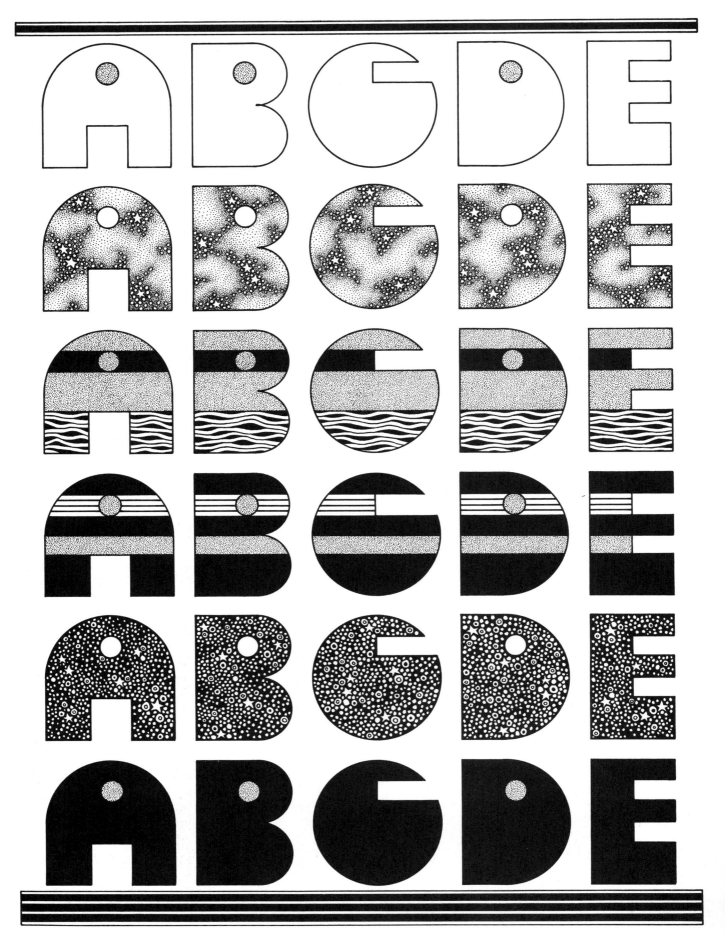

FGHIJK

FGHIJK

FGHIJK

FGHIJK

FGHIJK

FGHIJK

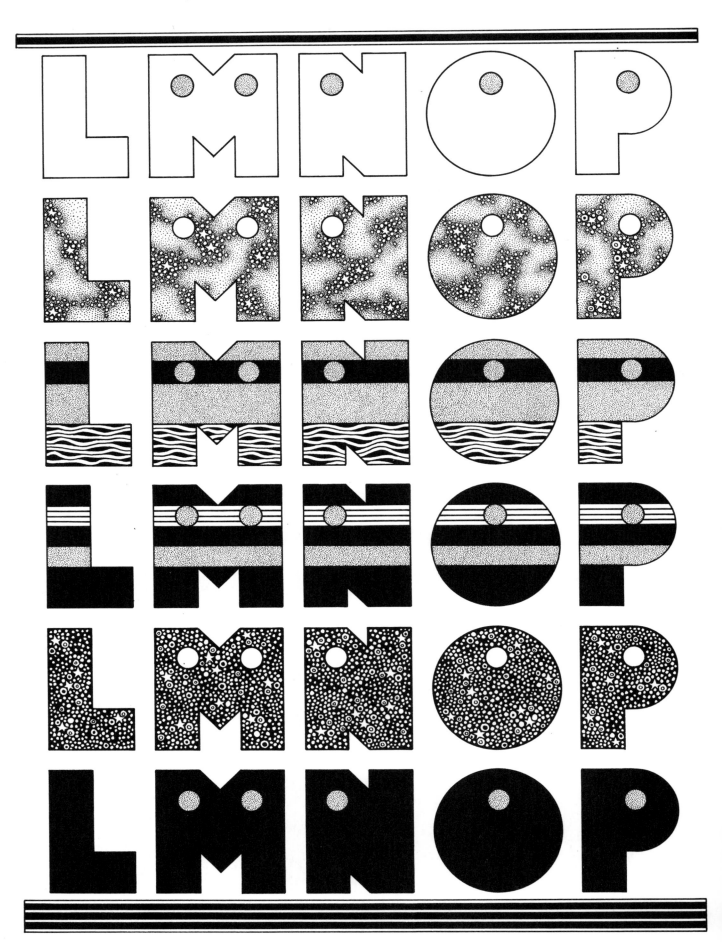

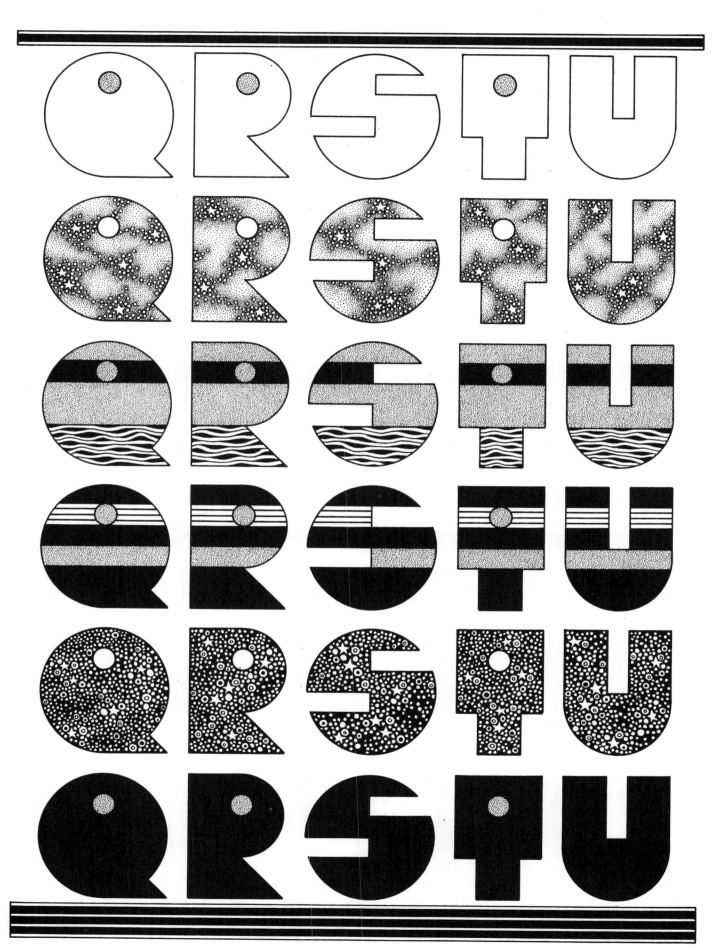

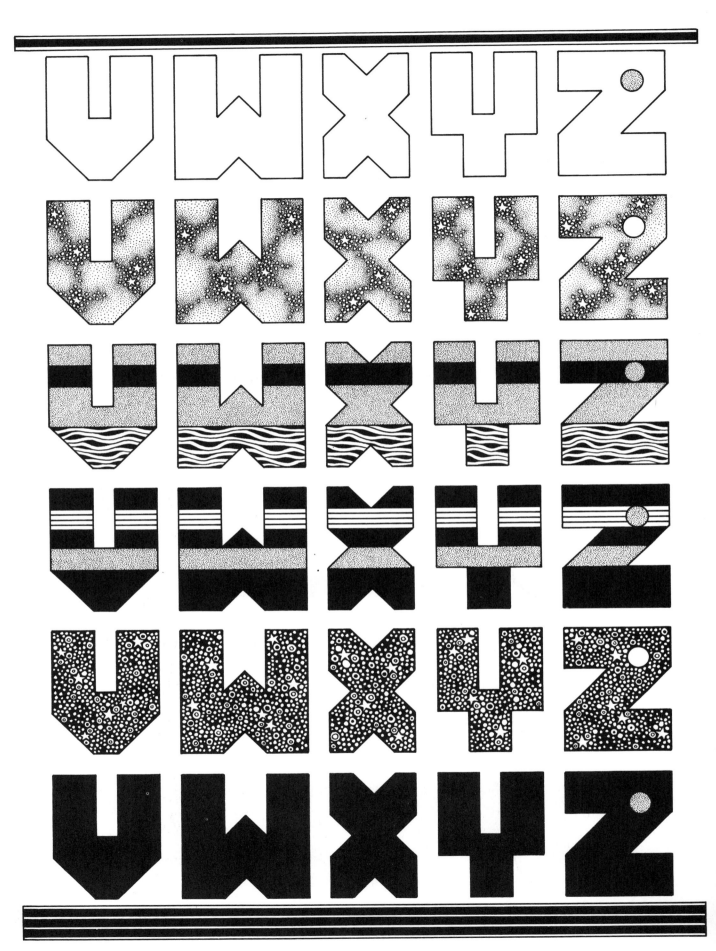

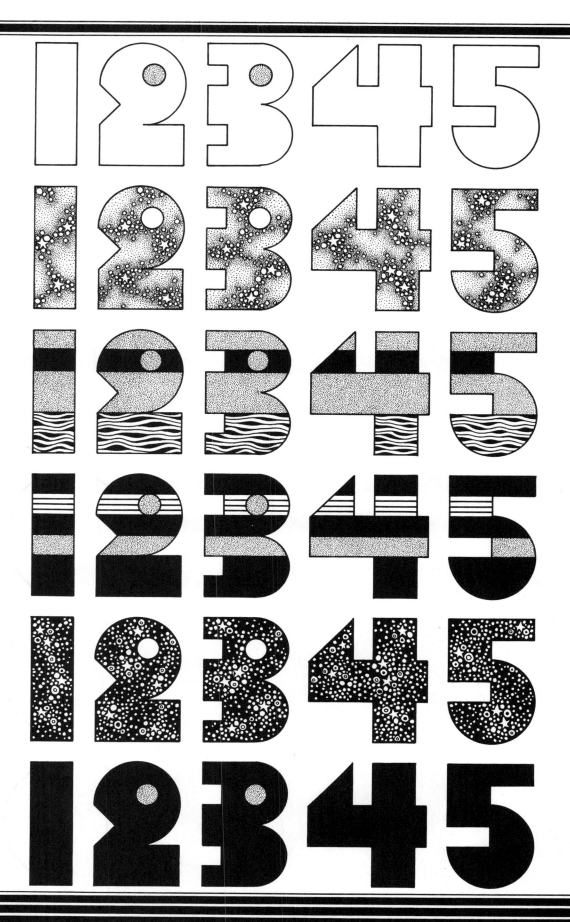

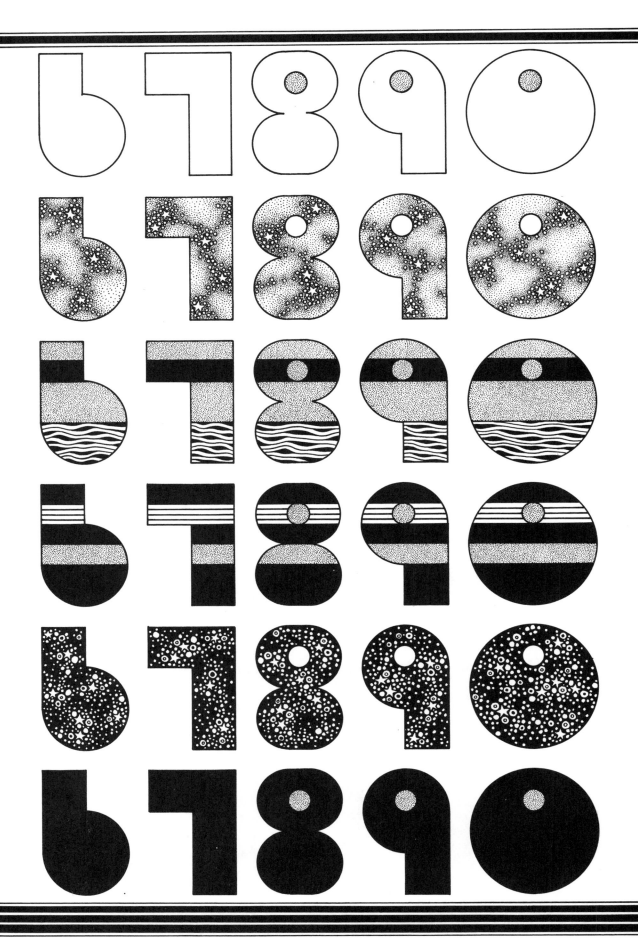

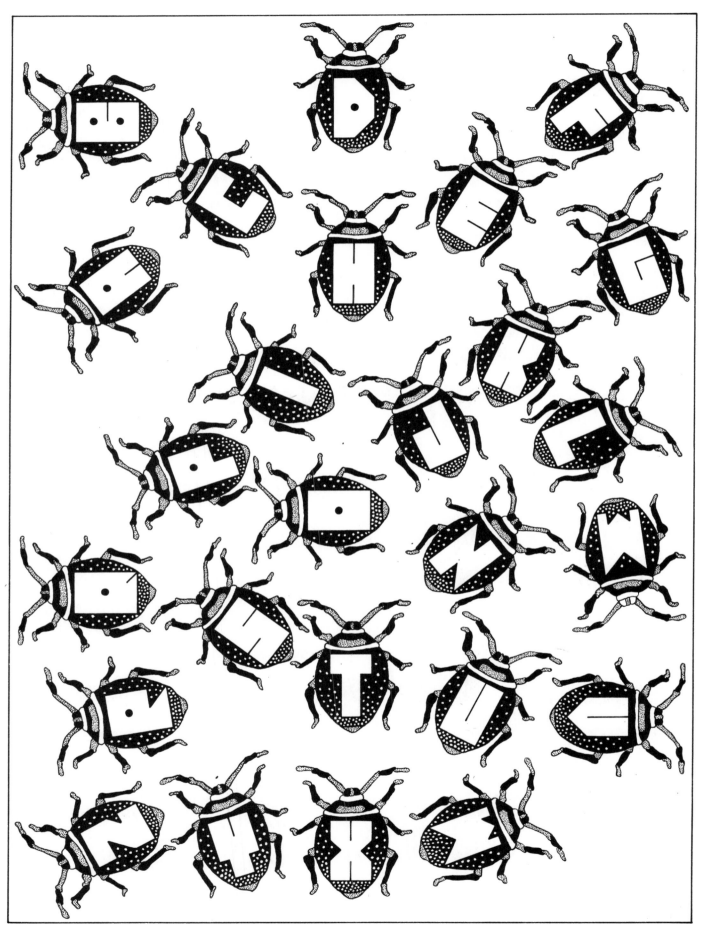

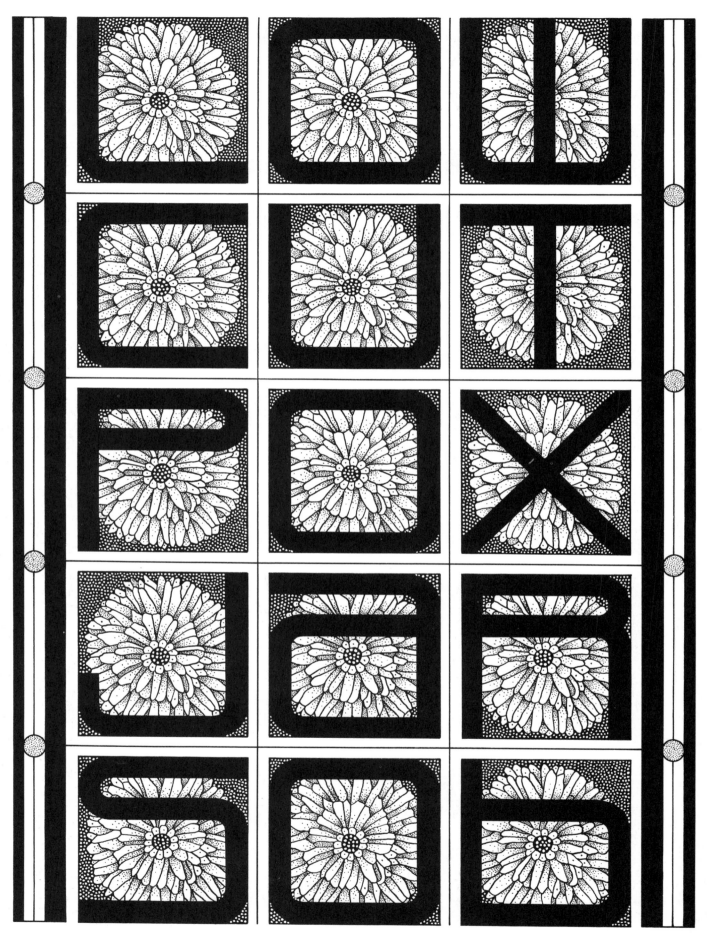

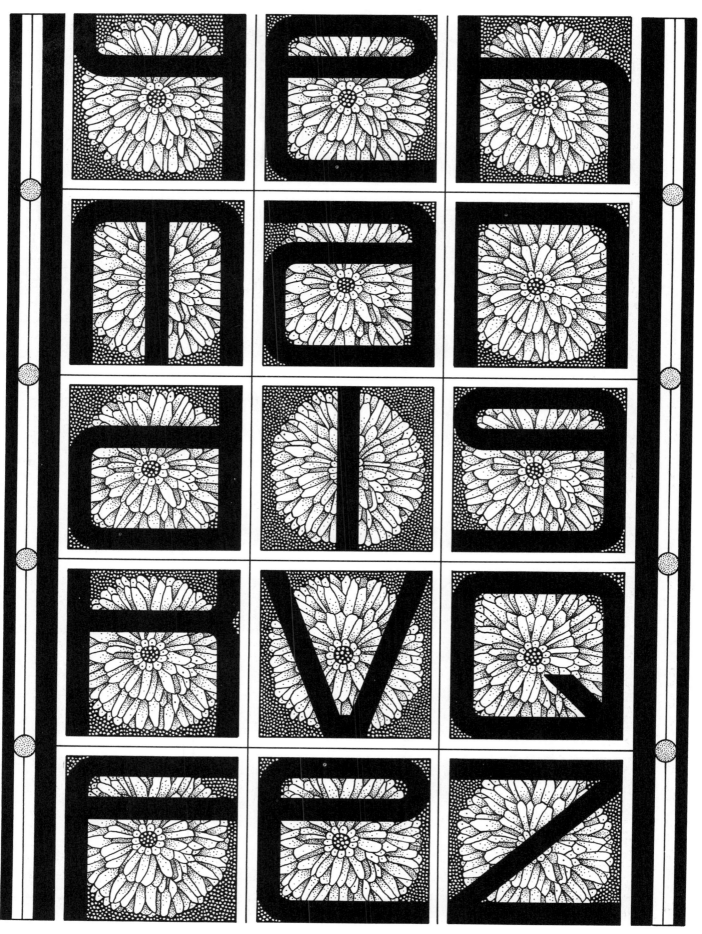

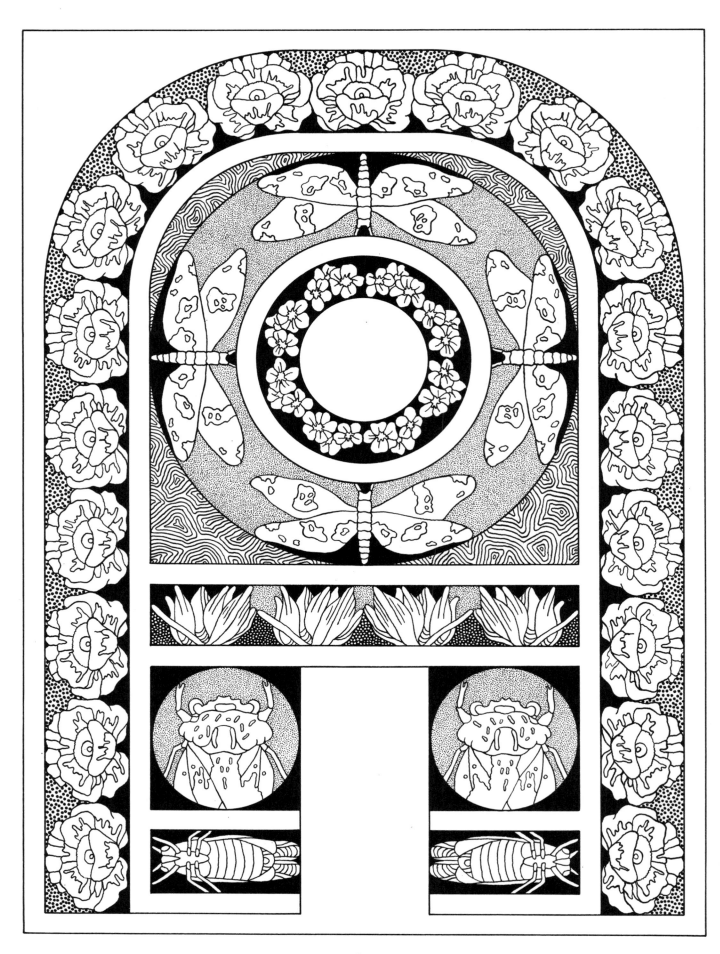

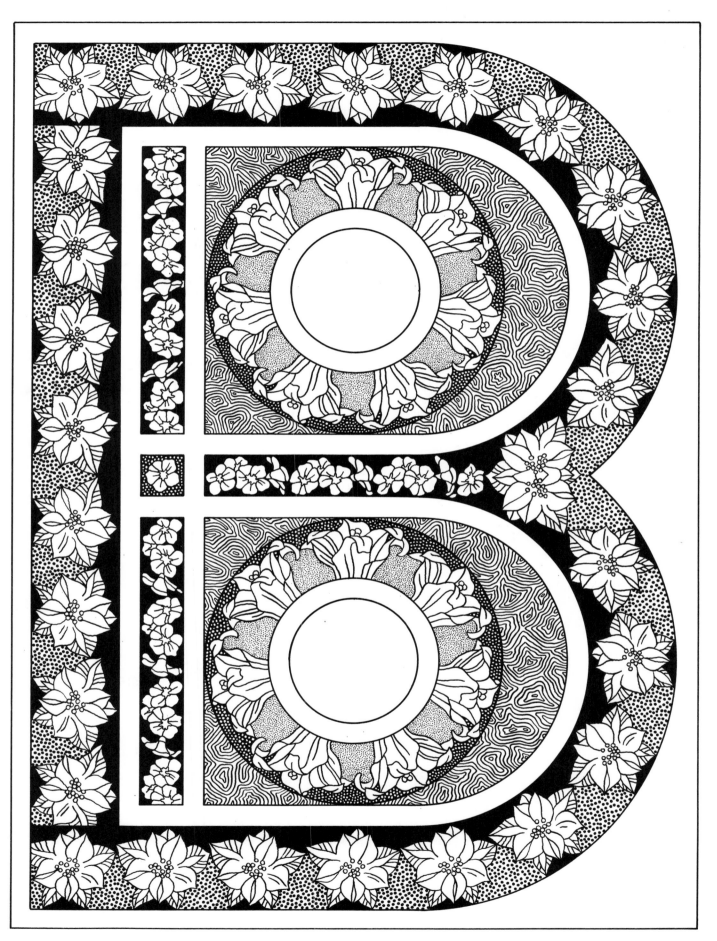

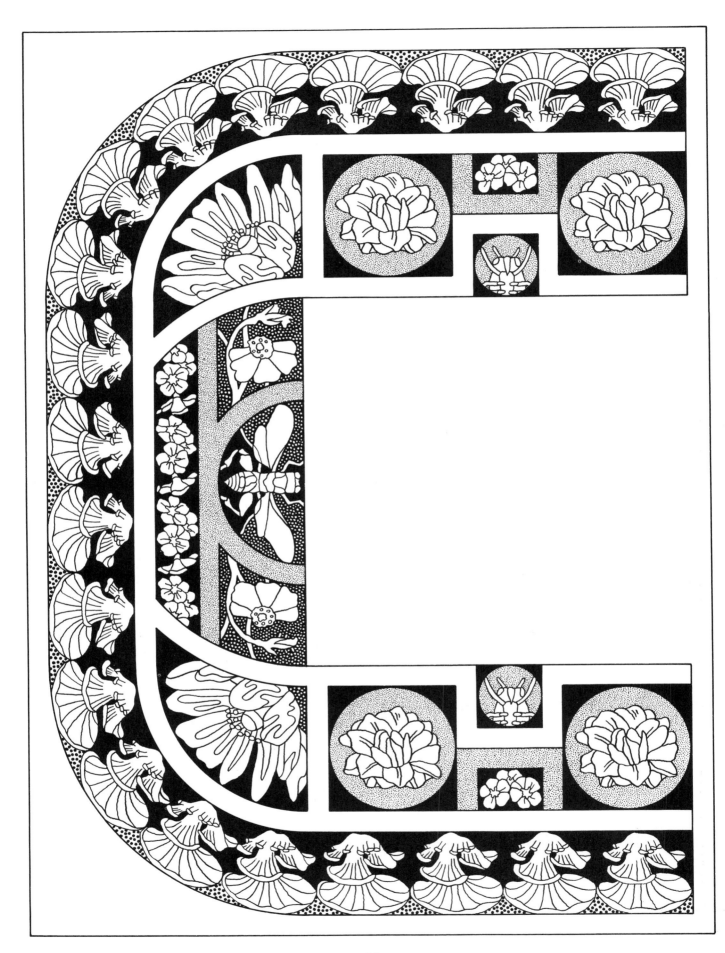

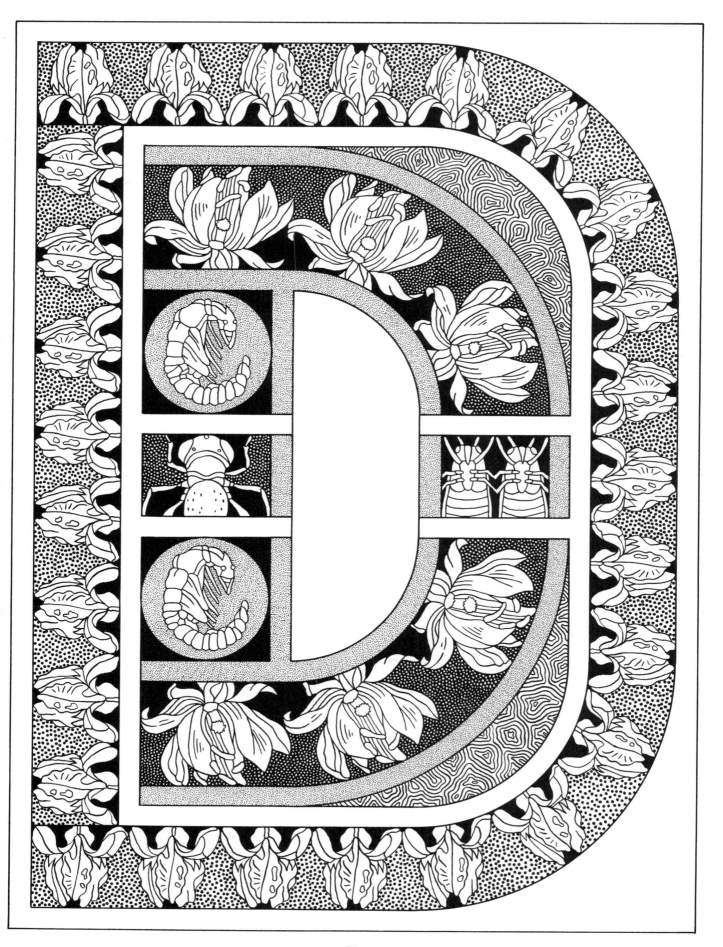

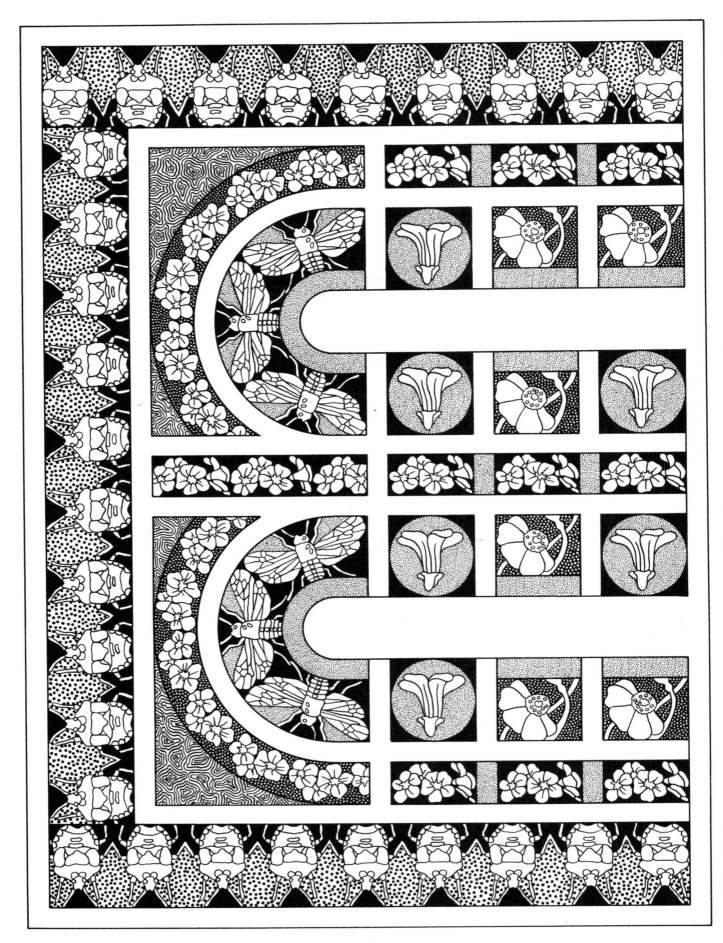

26

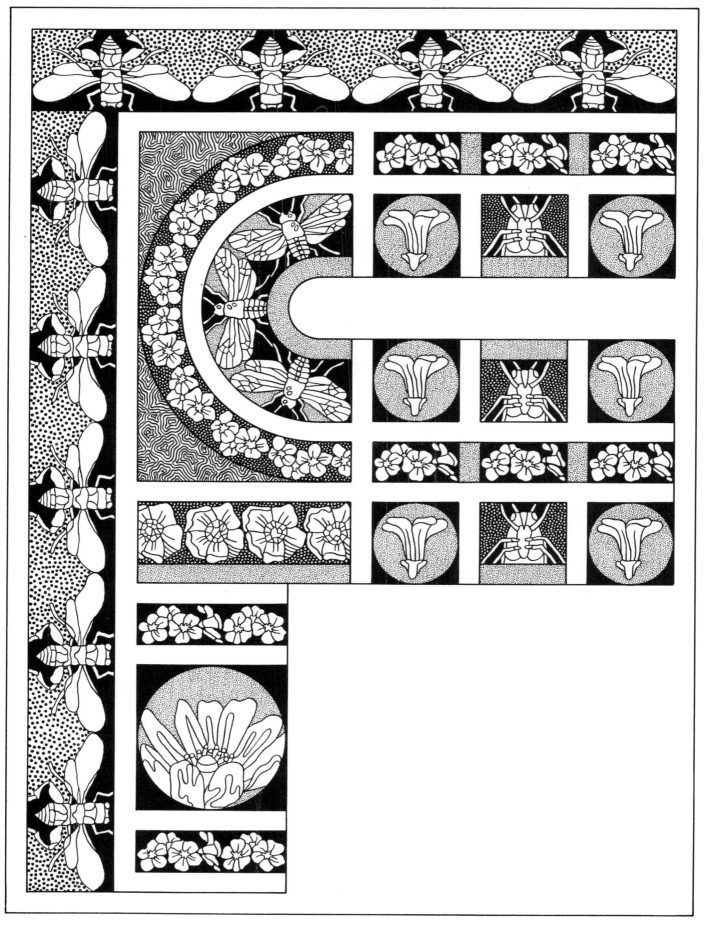

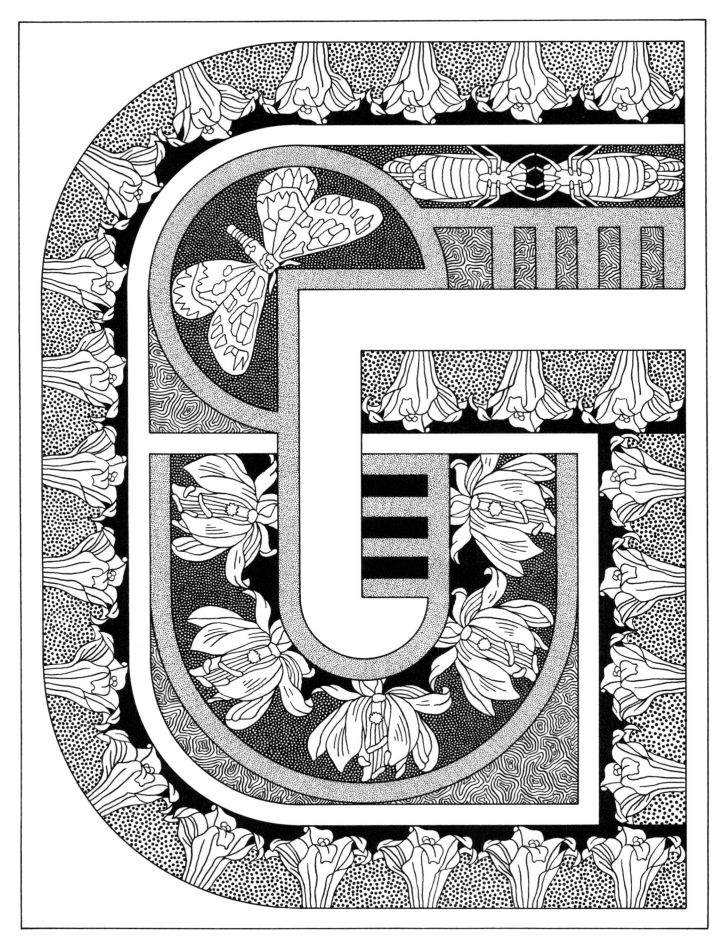

28

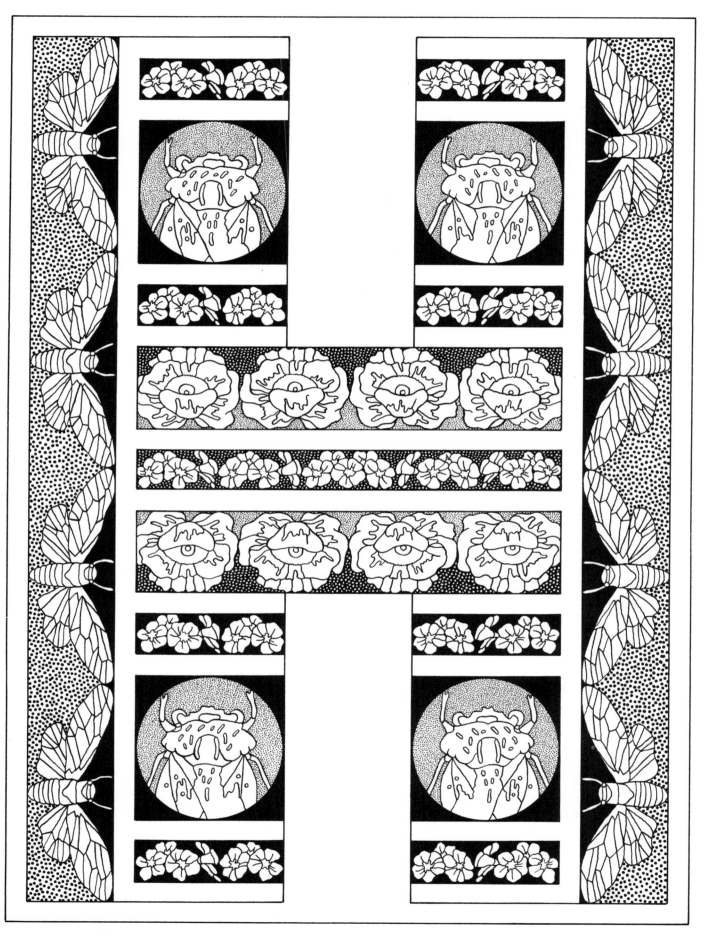

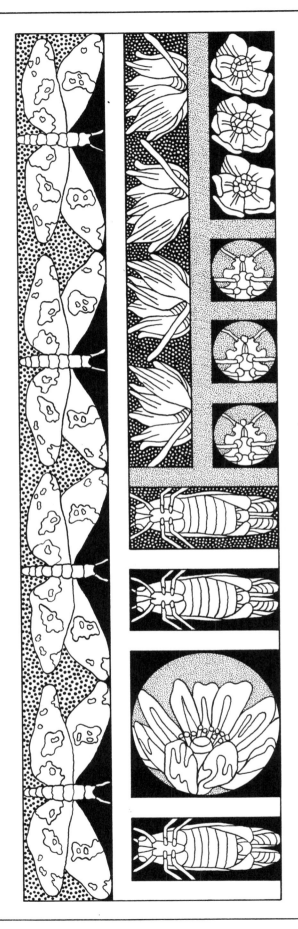

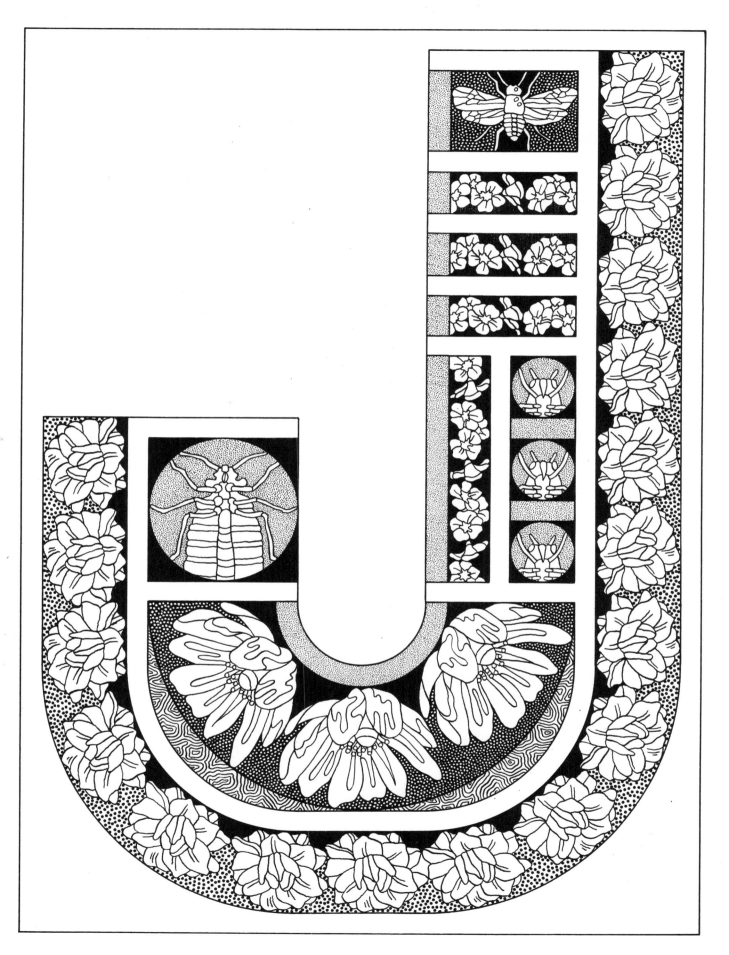

31

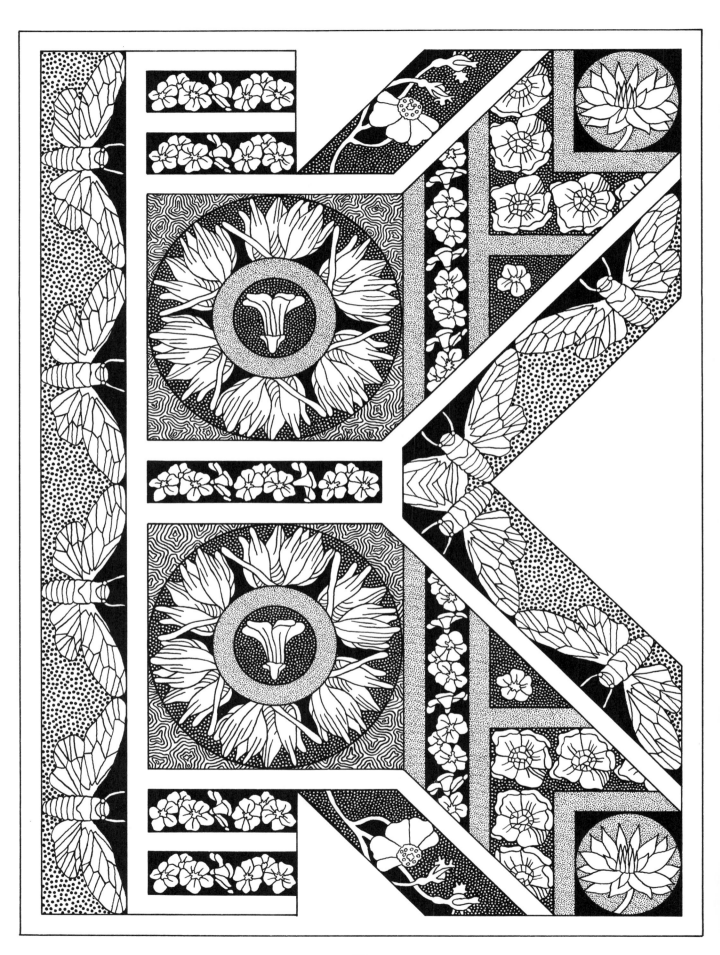

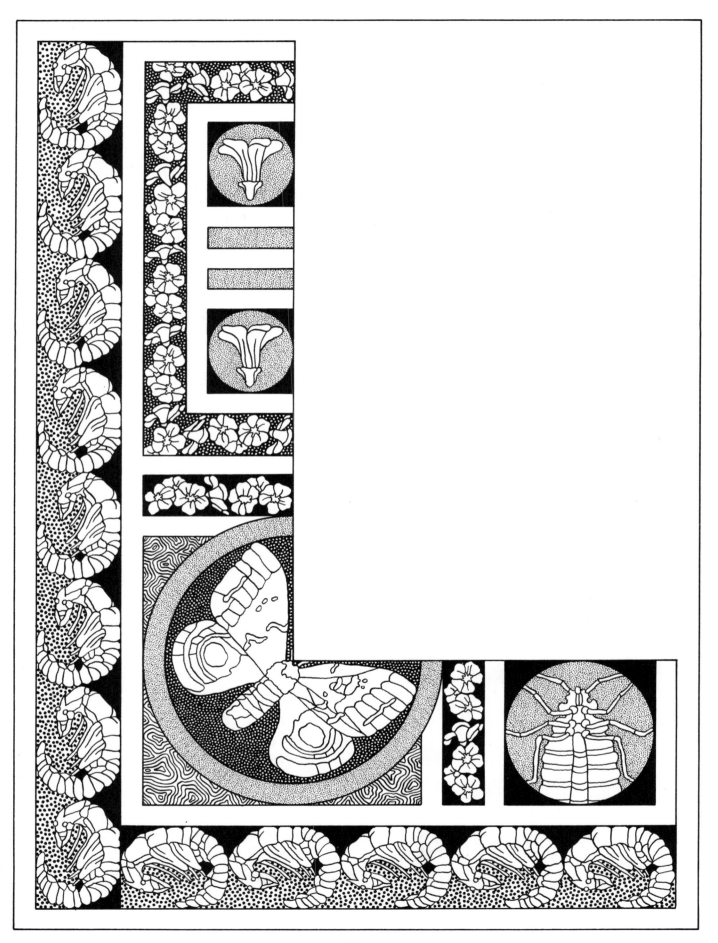

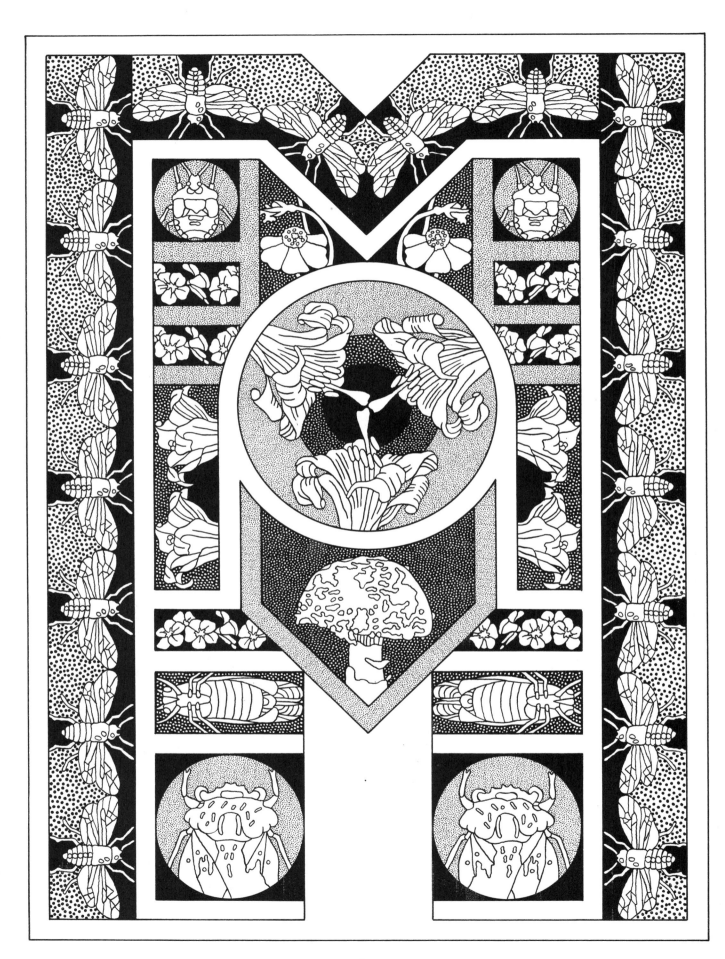

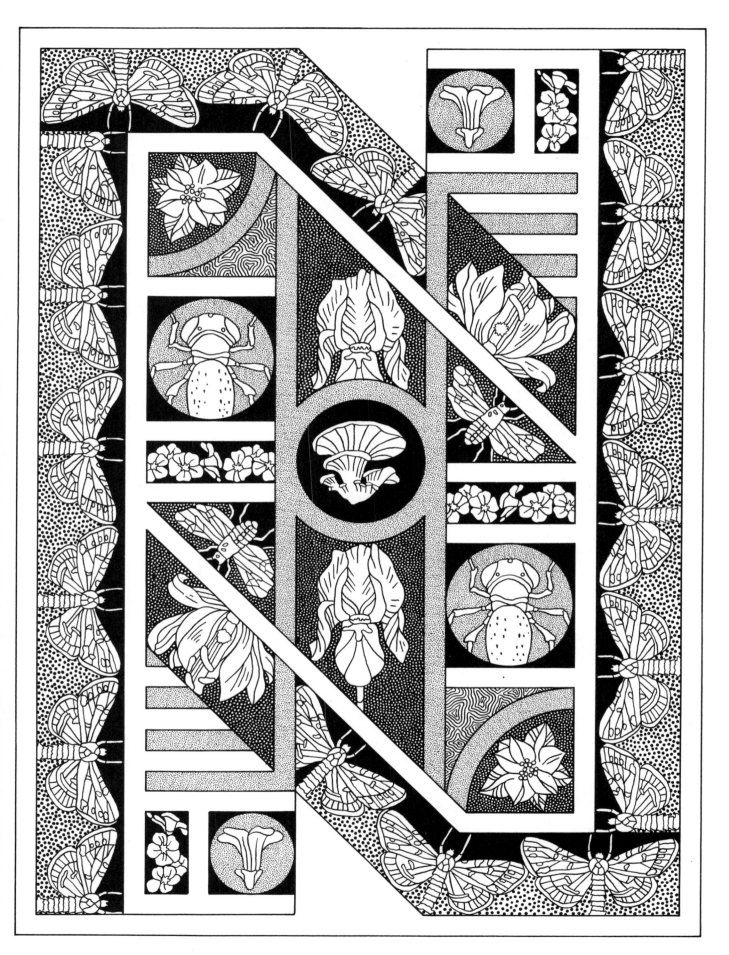

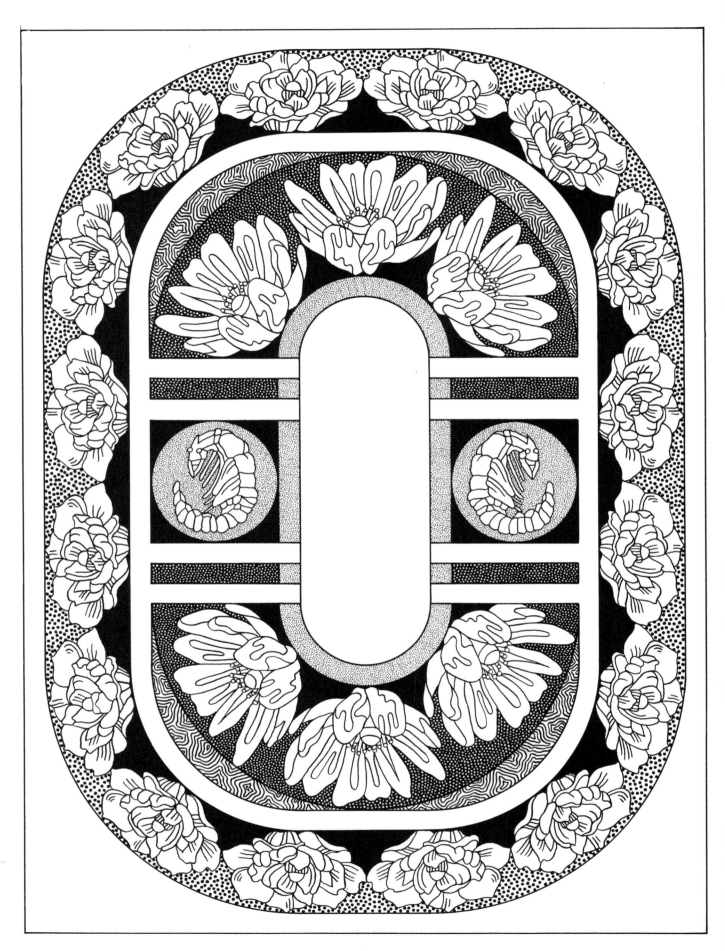

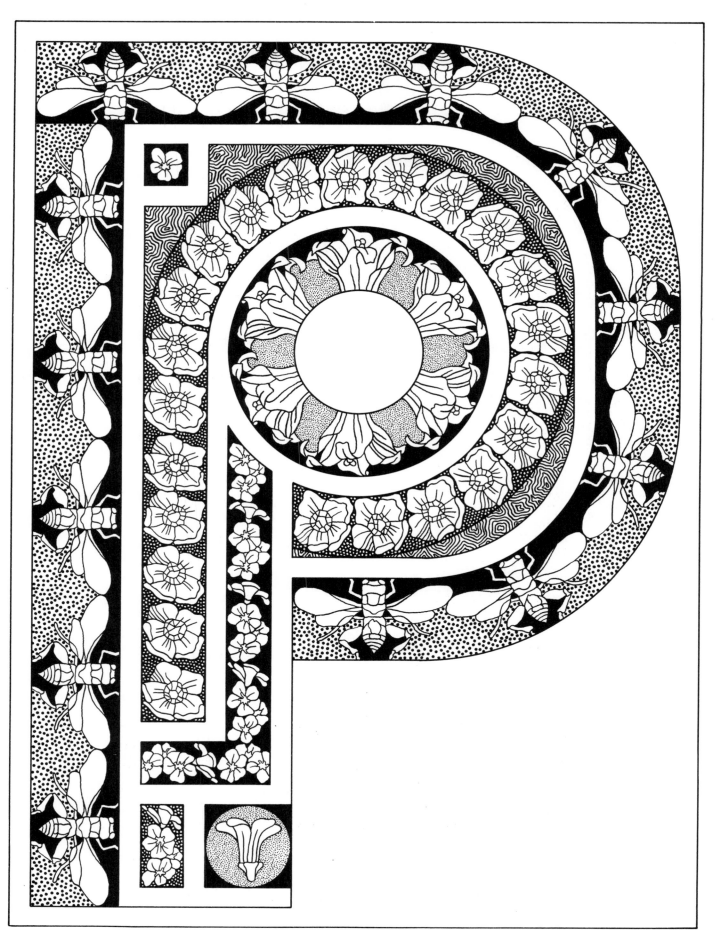

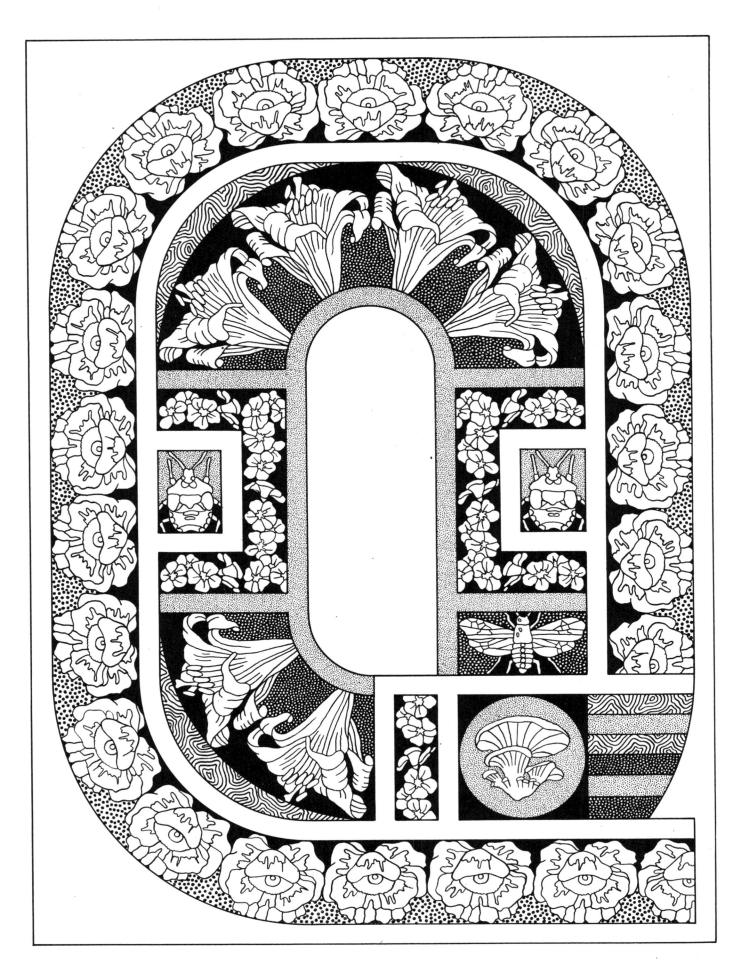

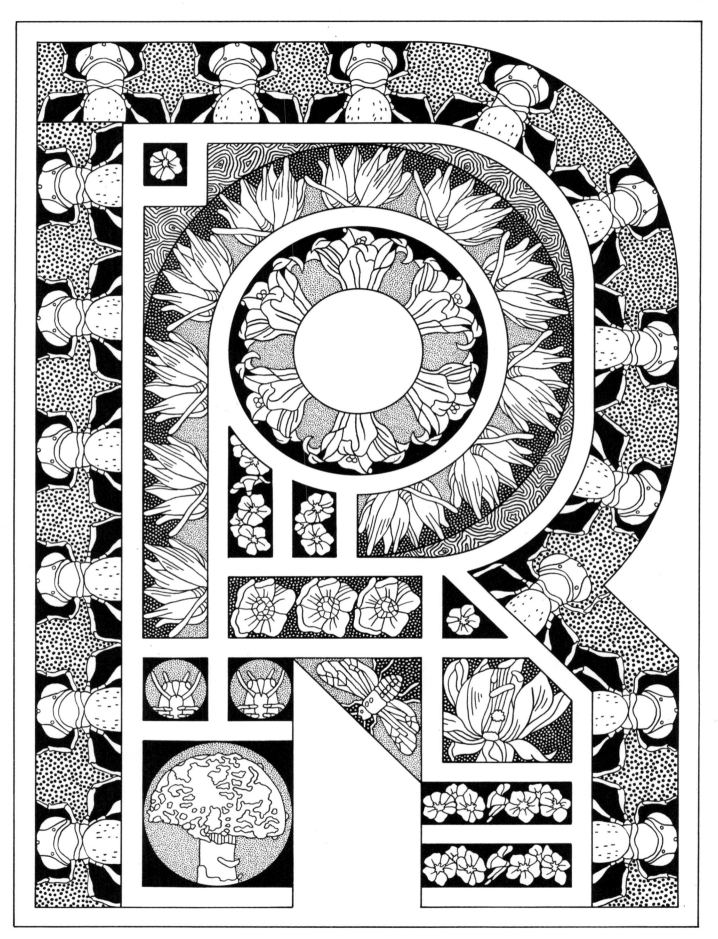

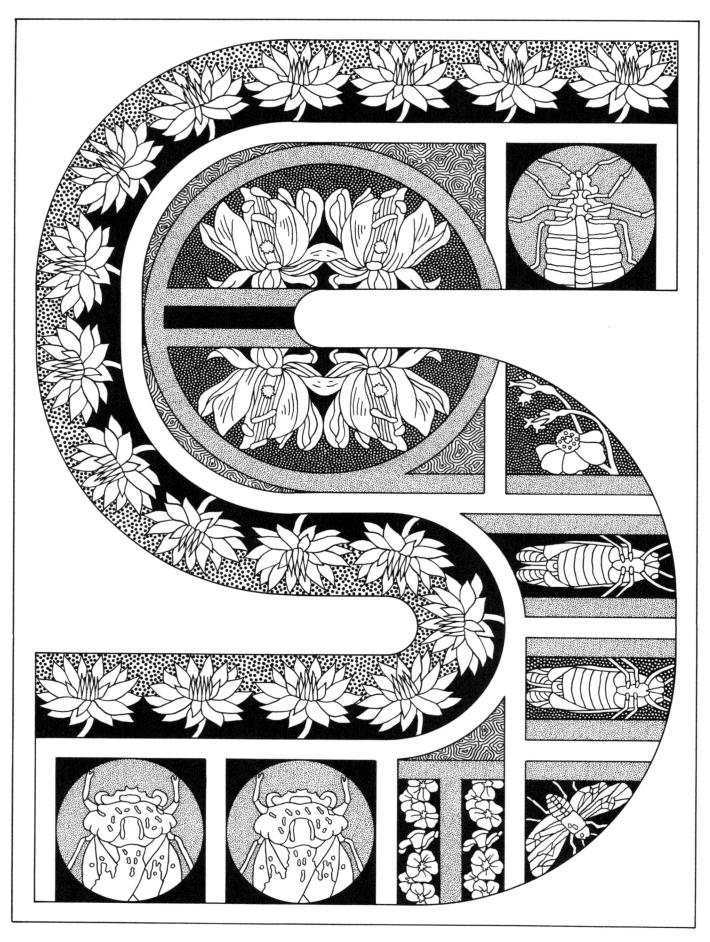

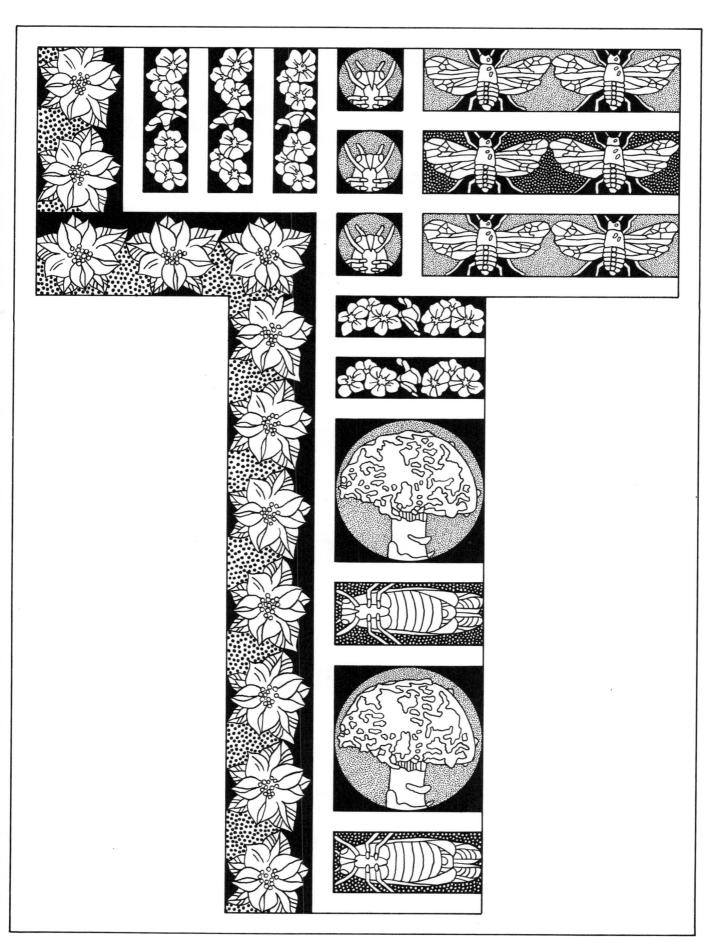

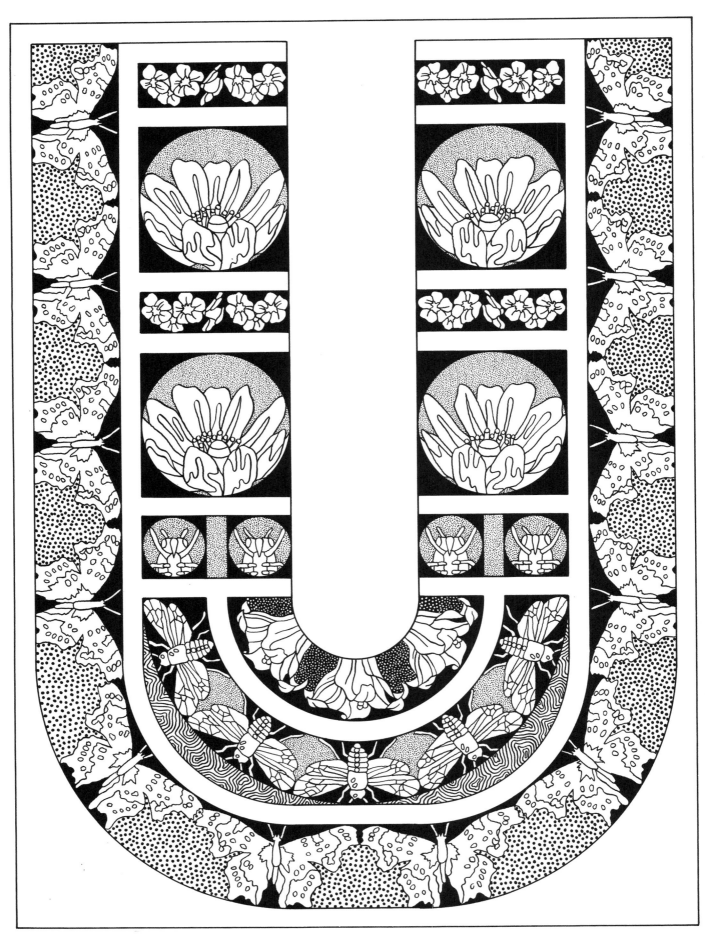

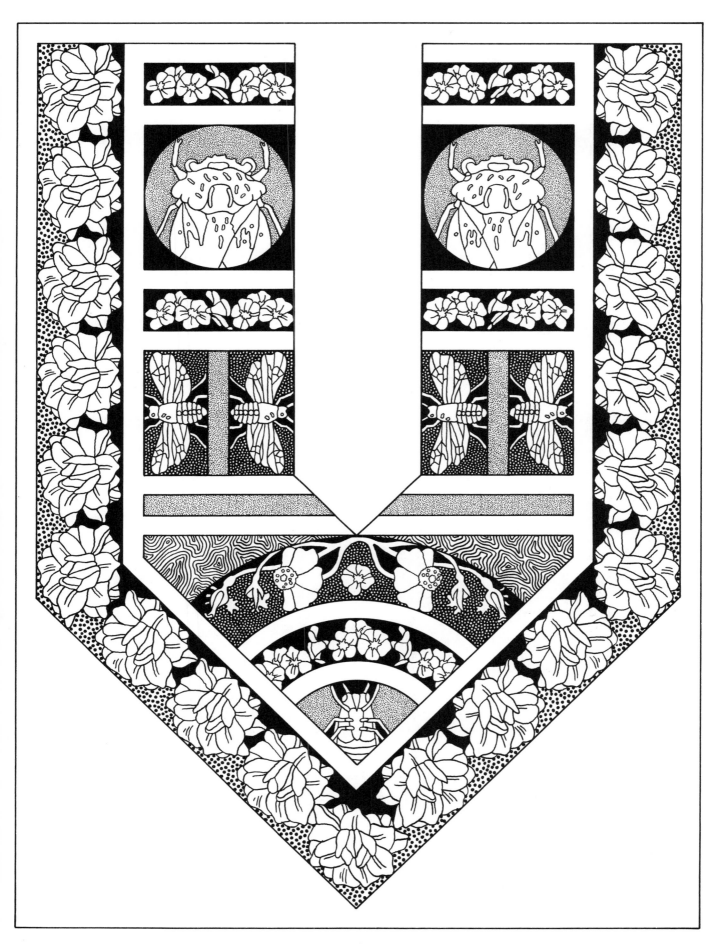

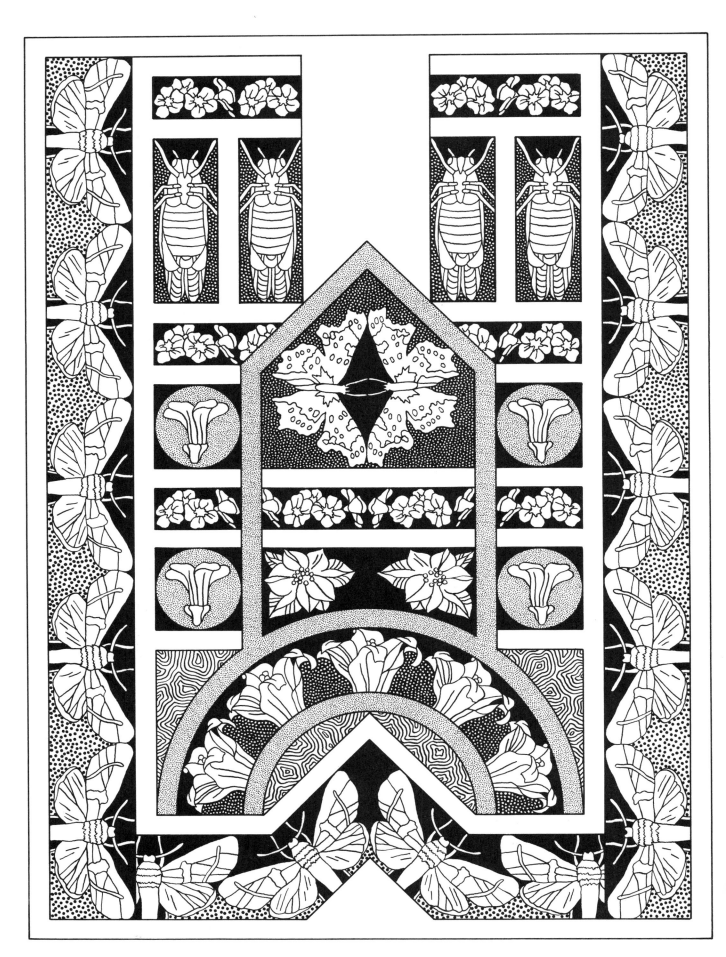

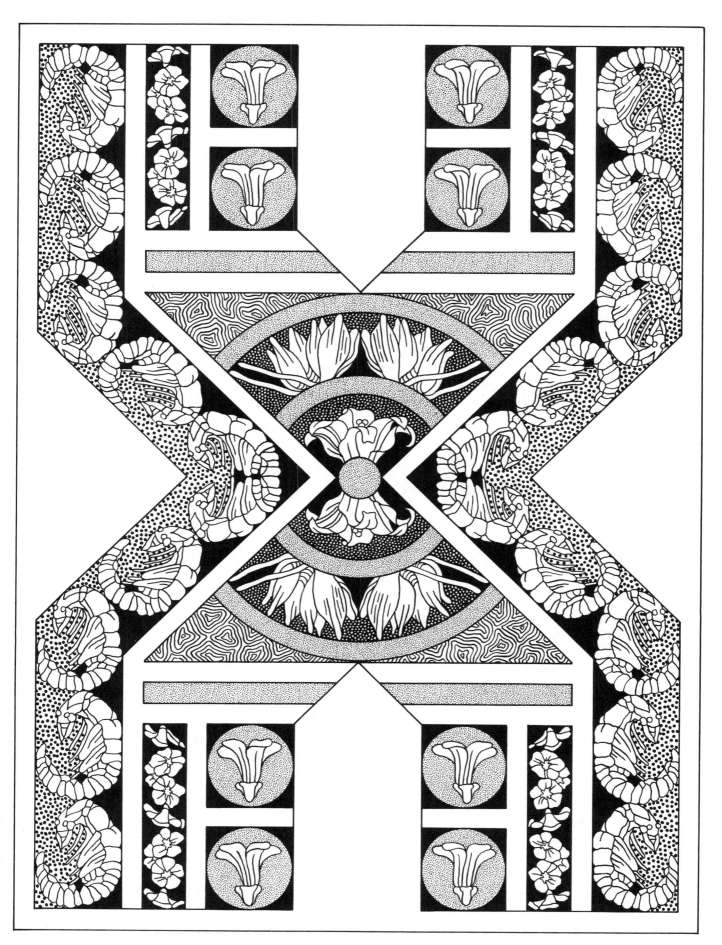

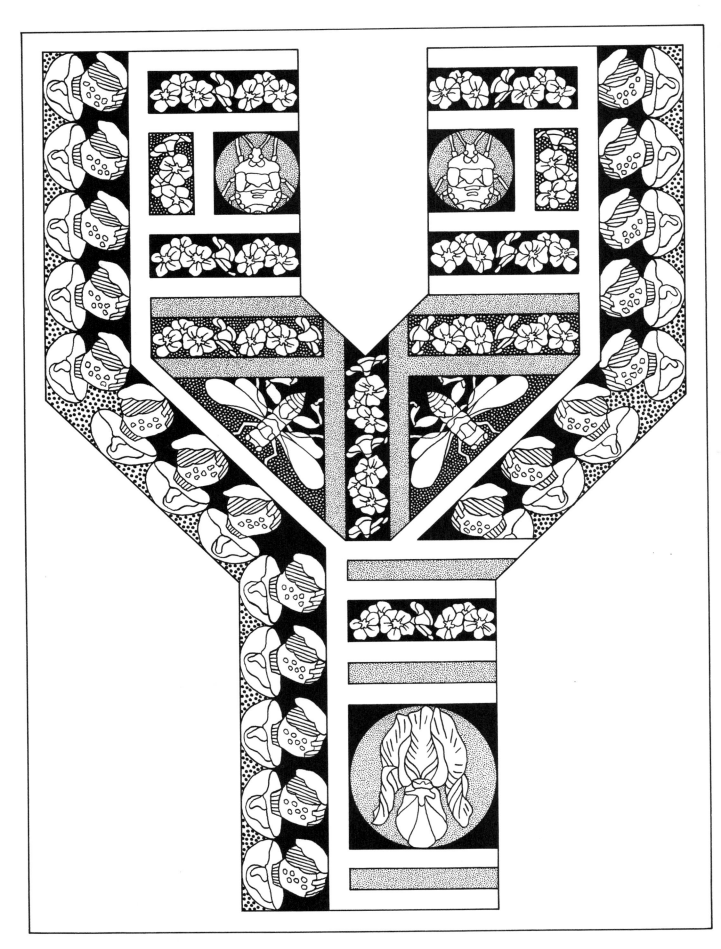

46

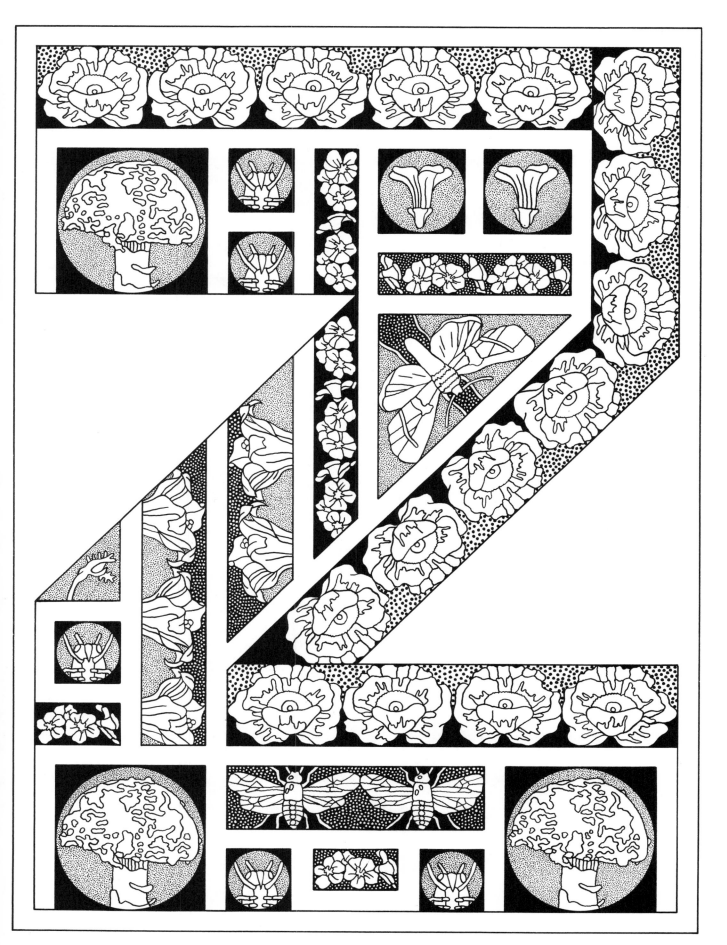

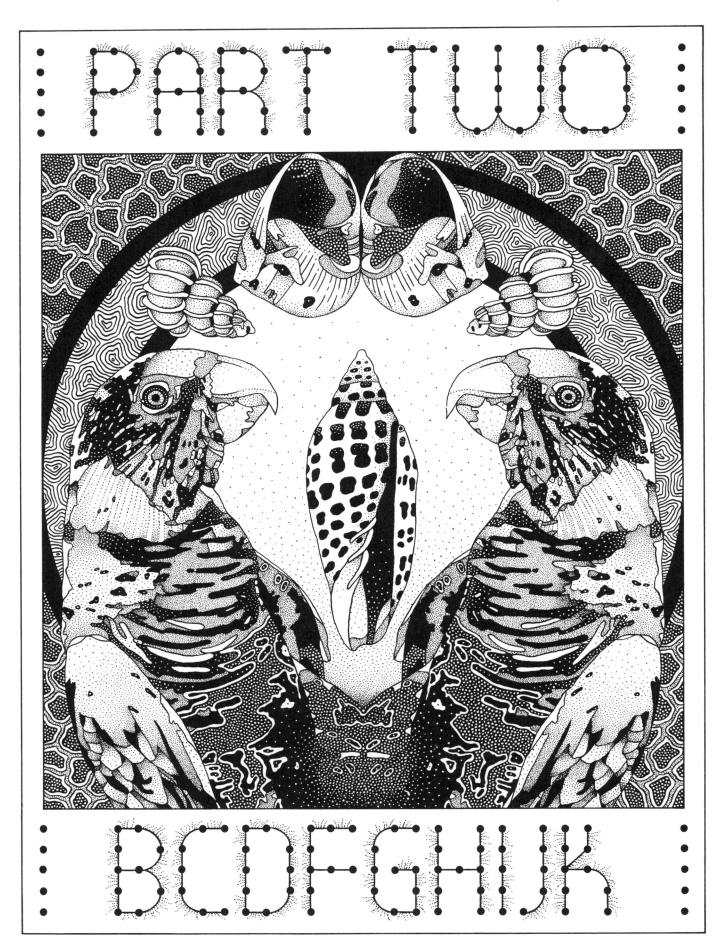

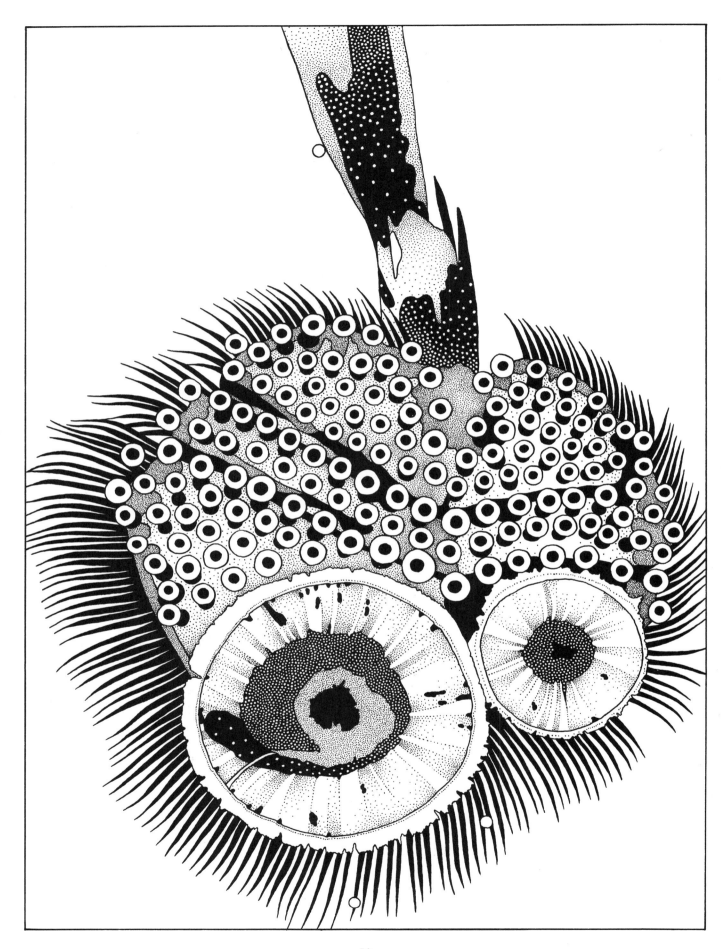

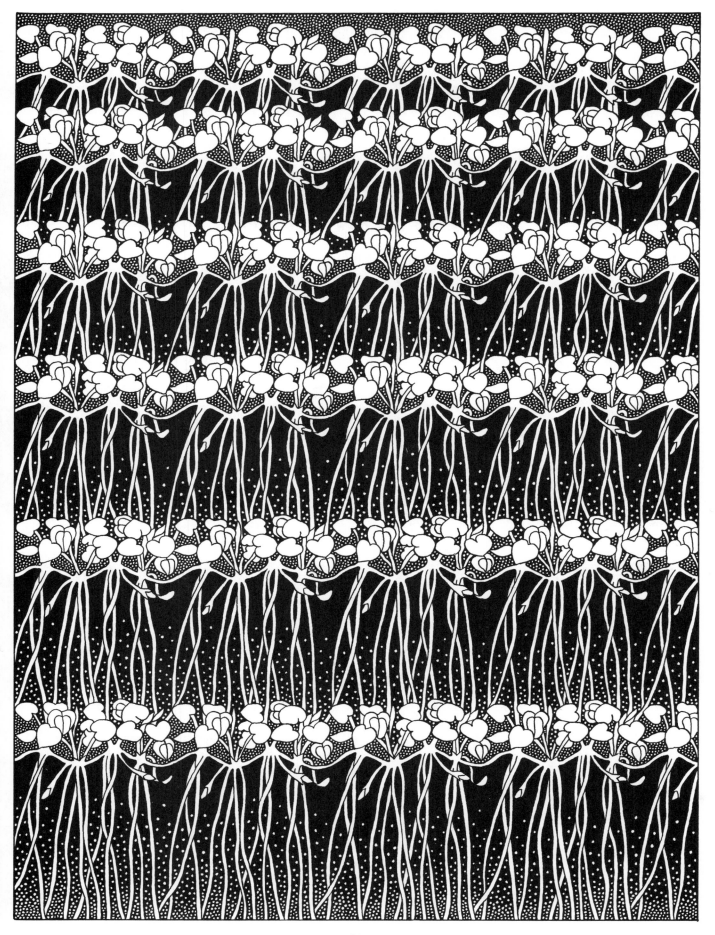

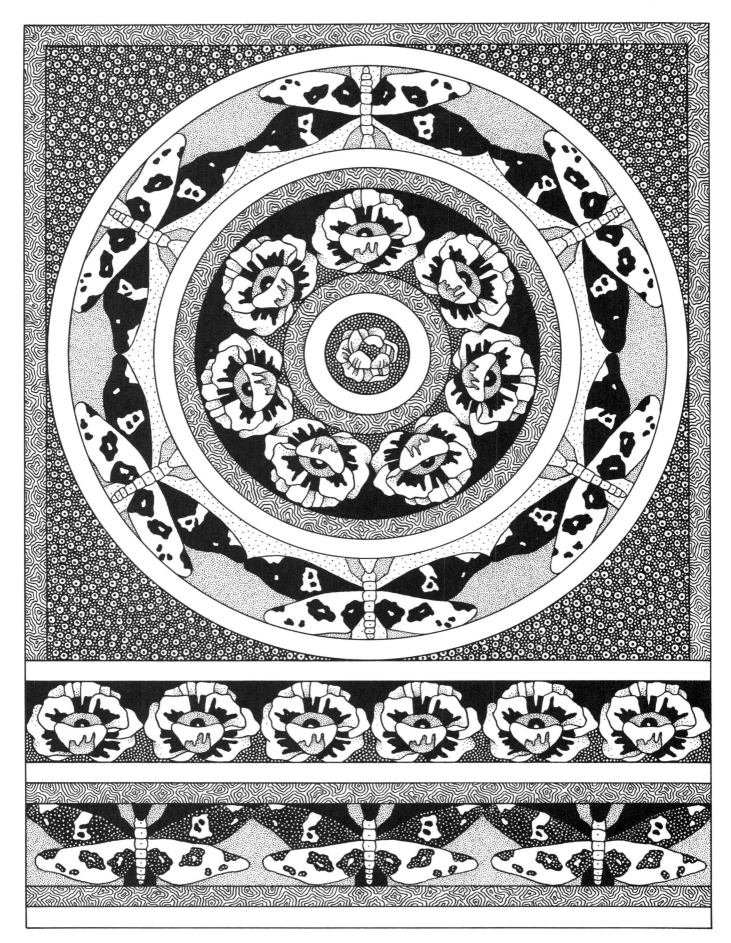

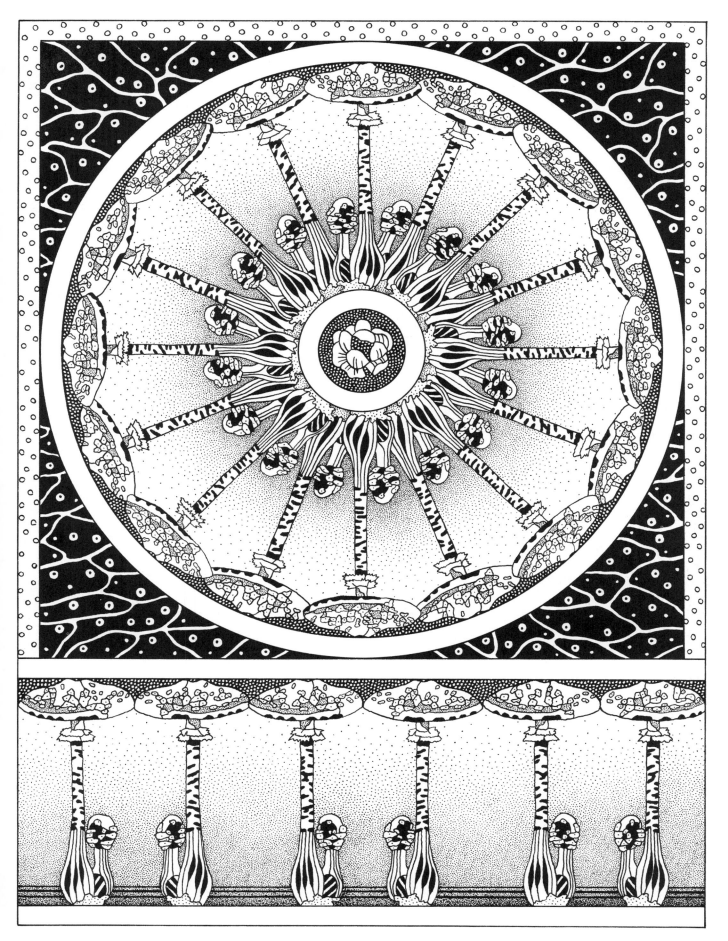

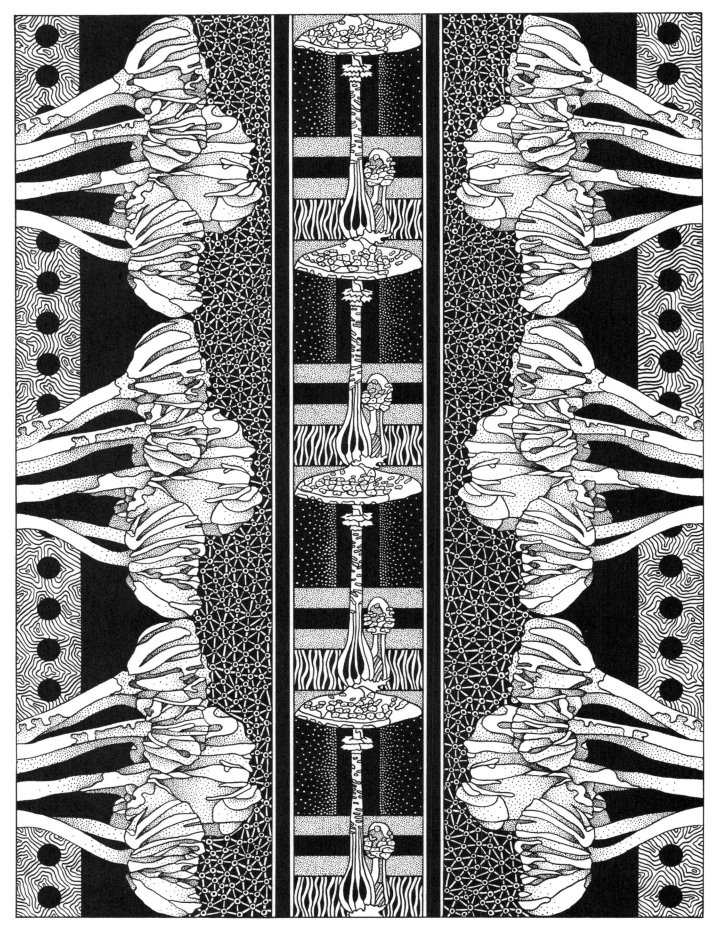

54

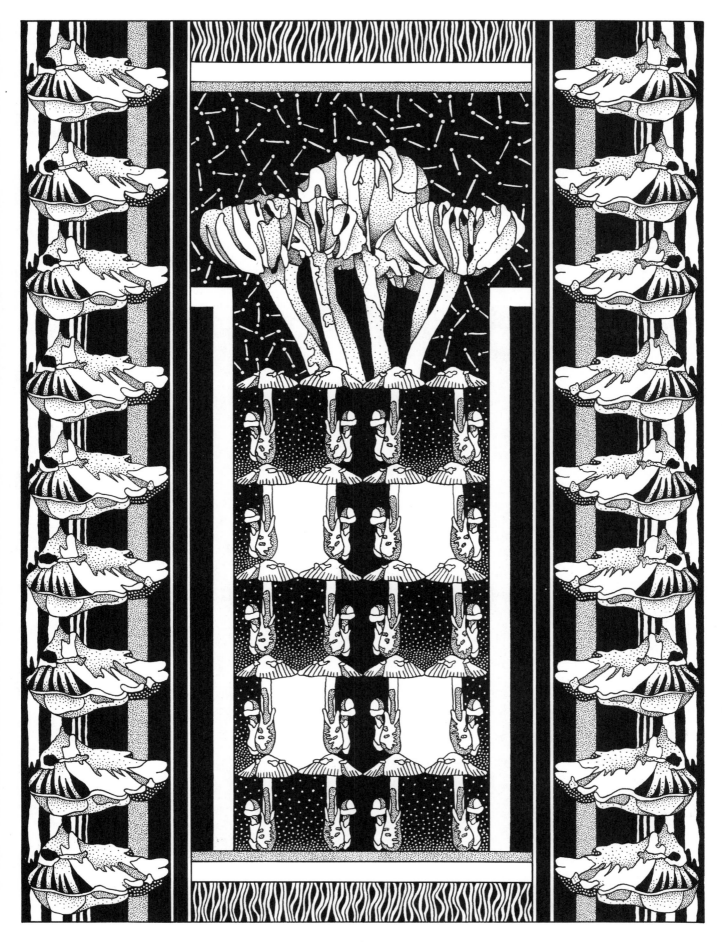

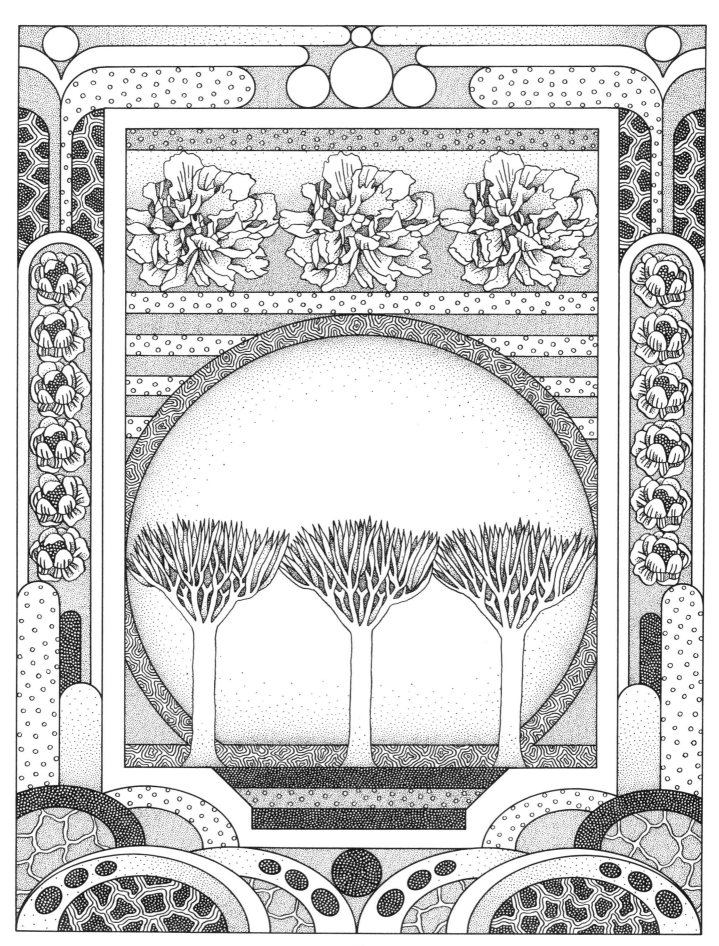

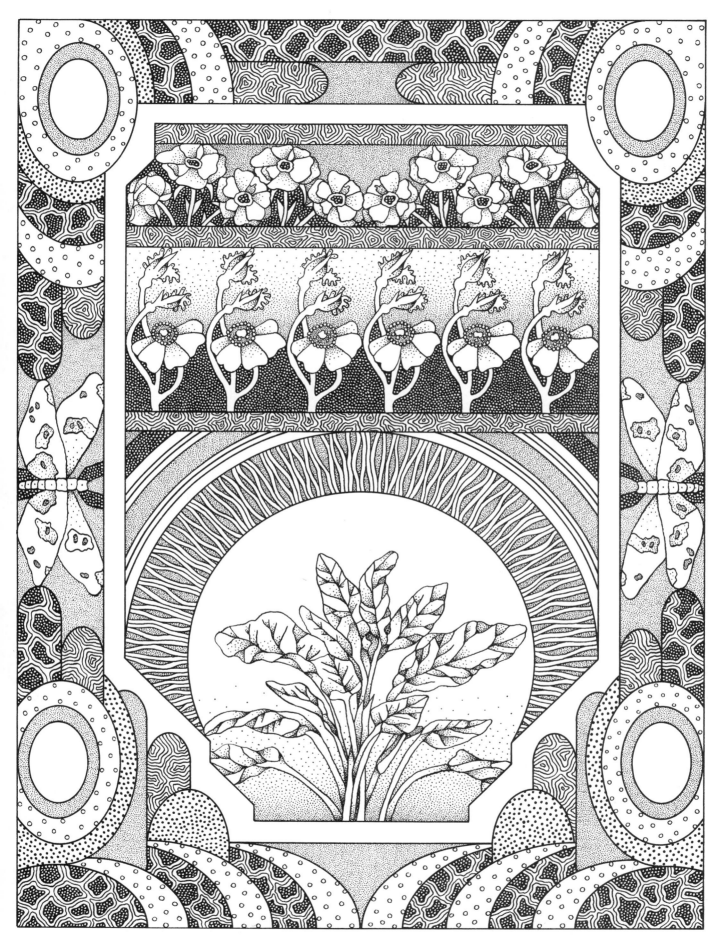

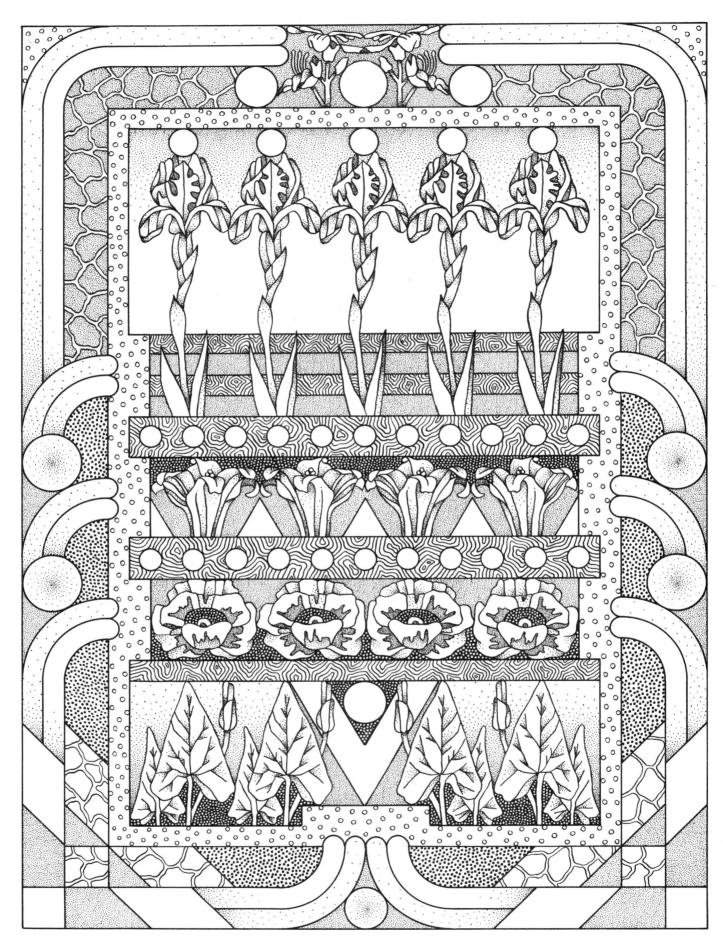

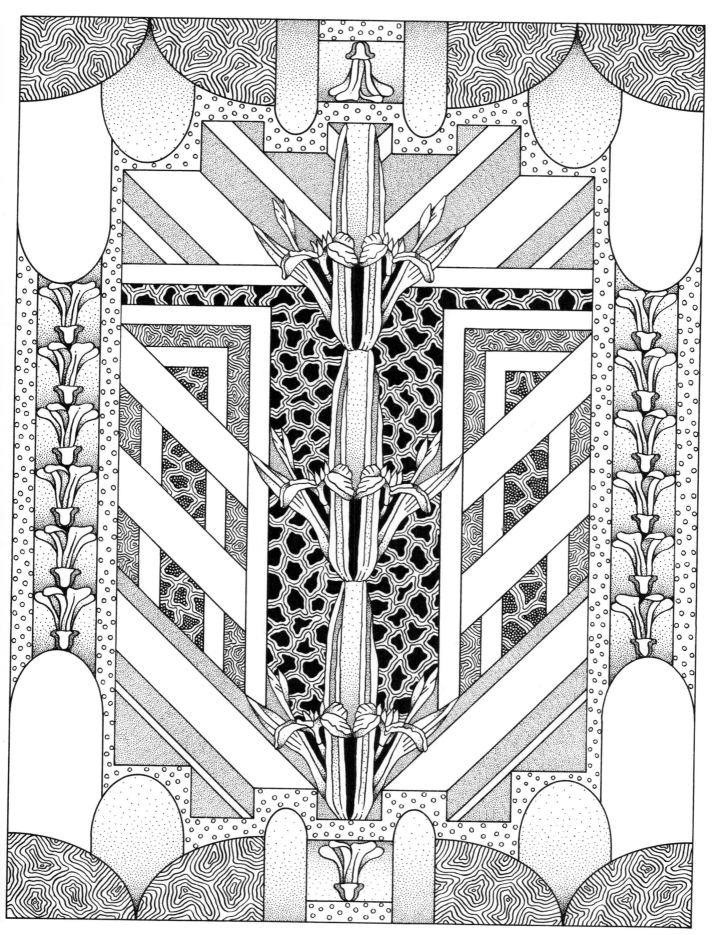

59

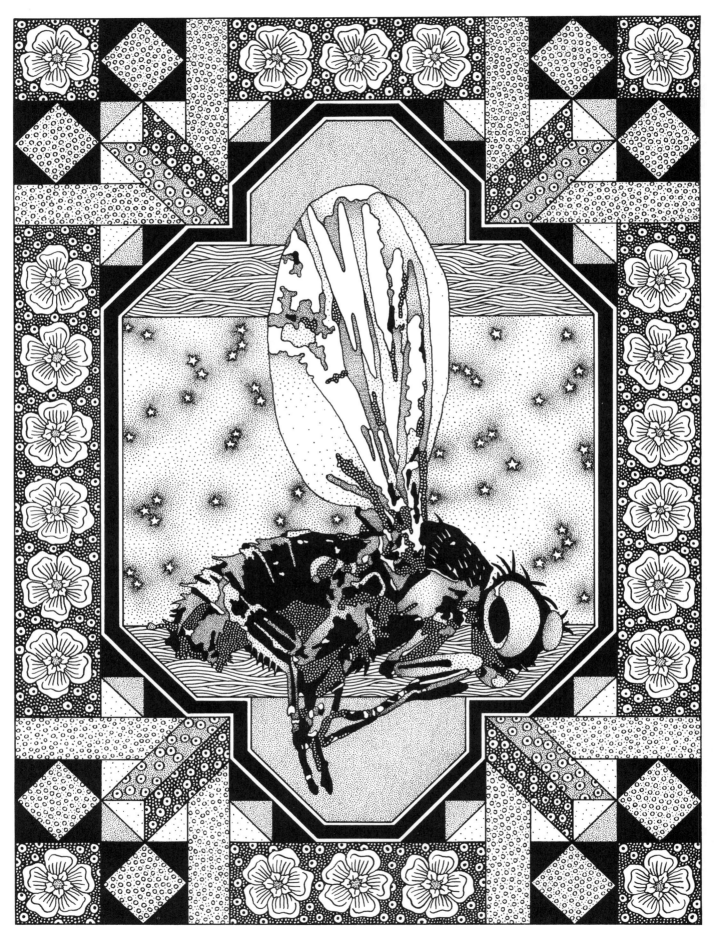

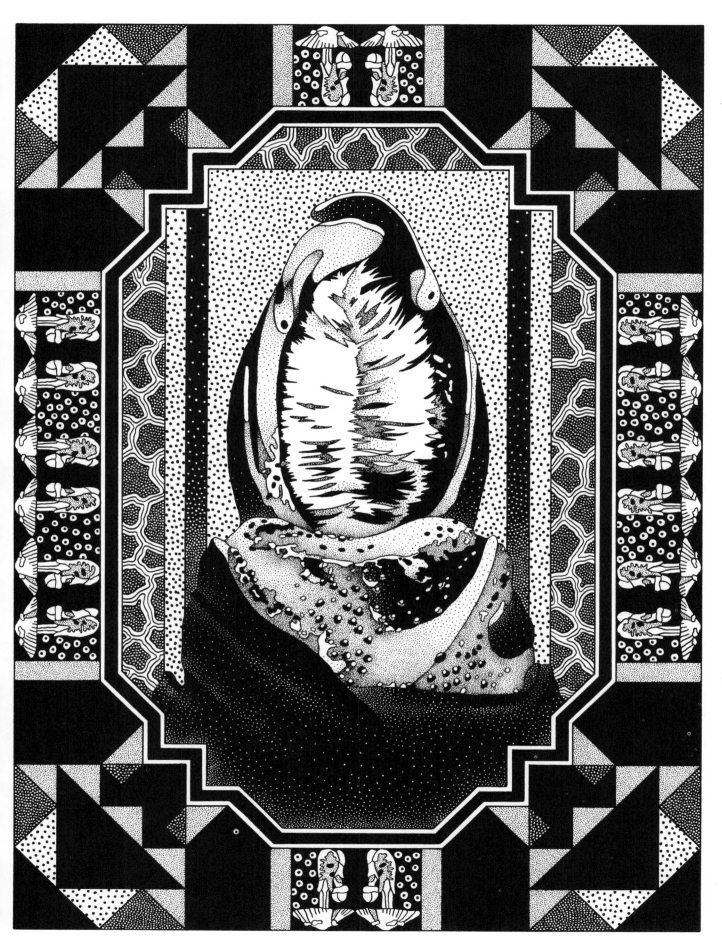

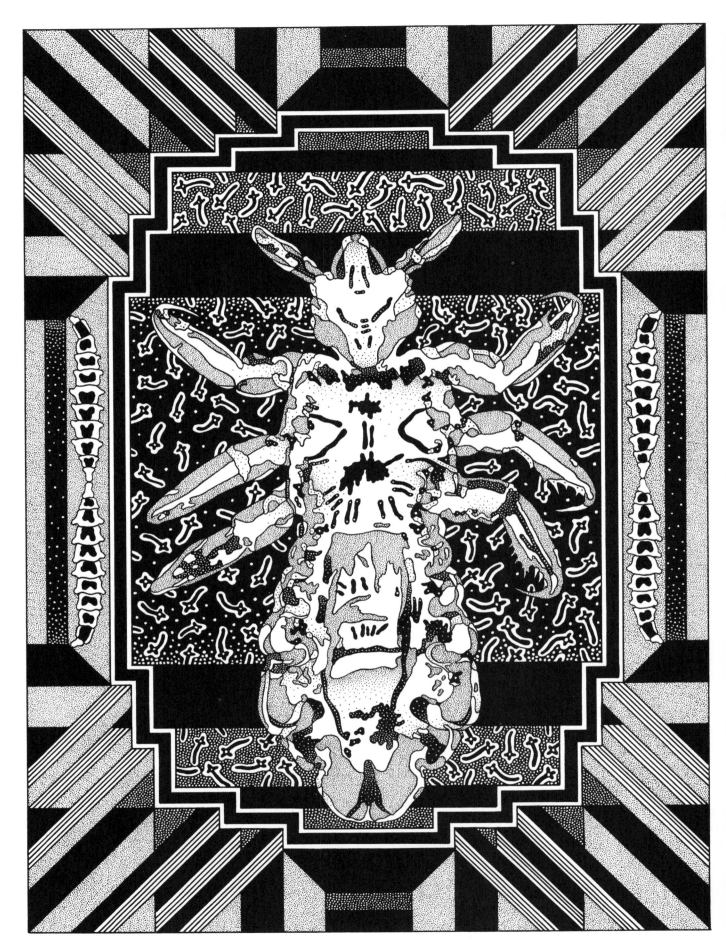

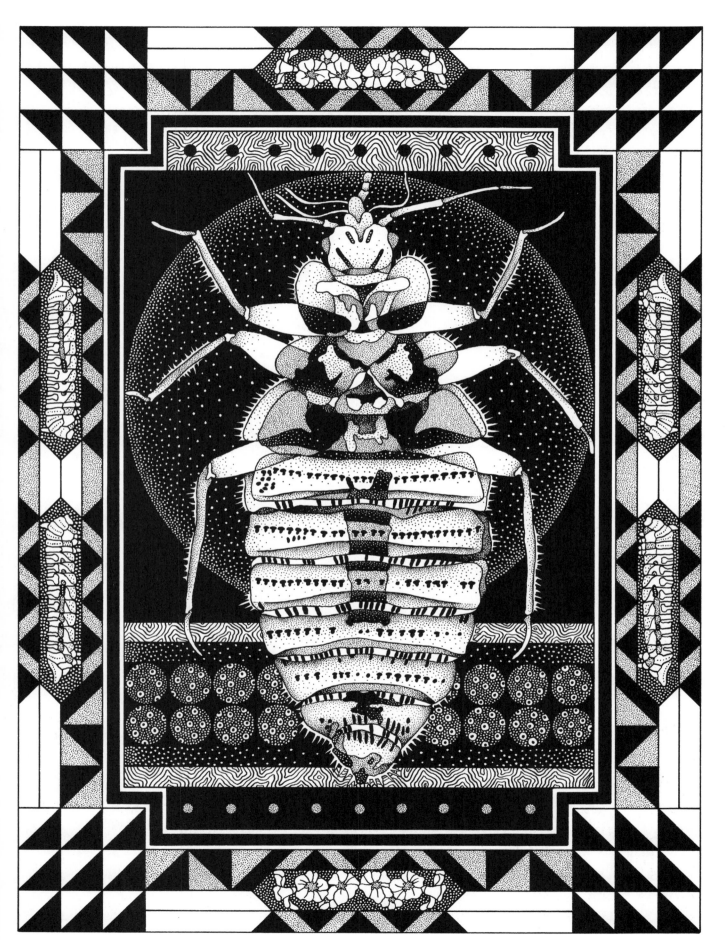

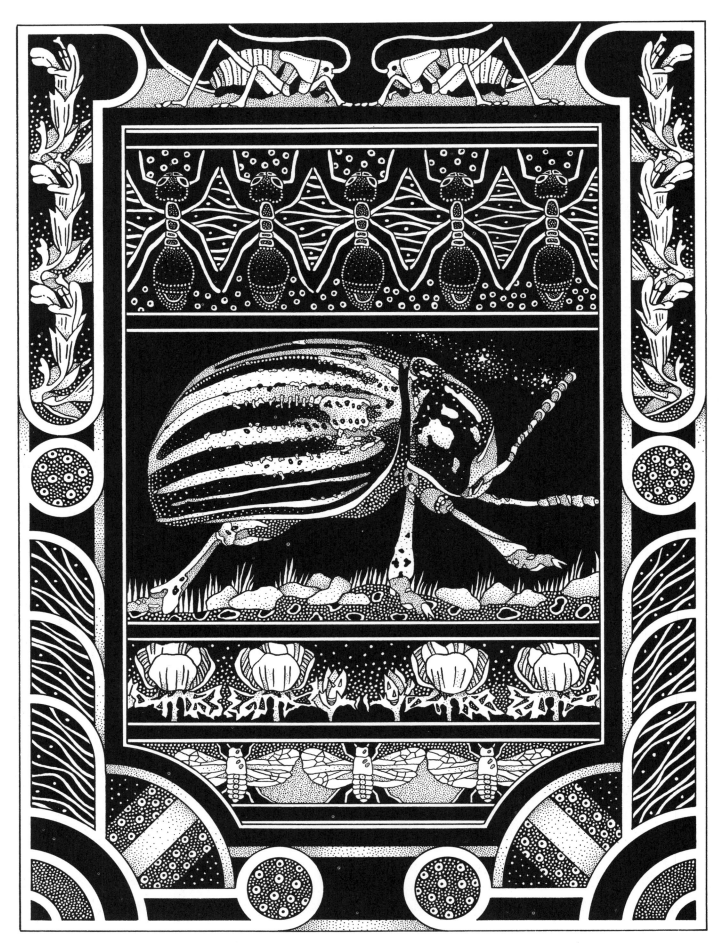

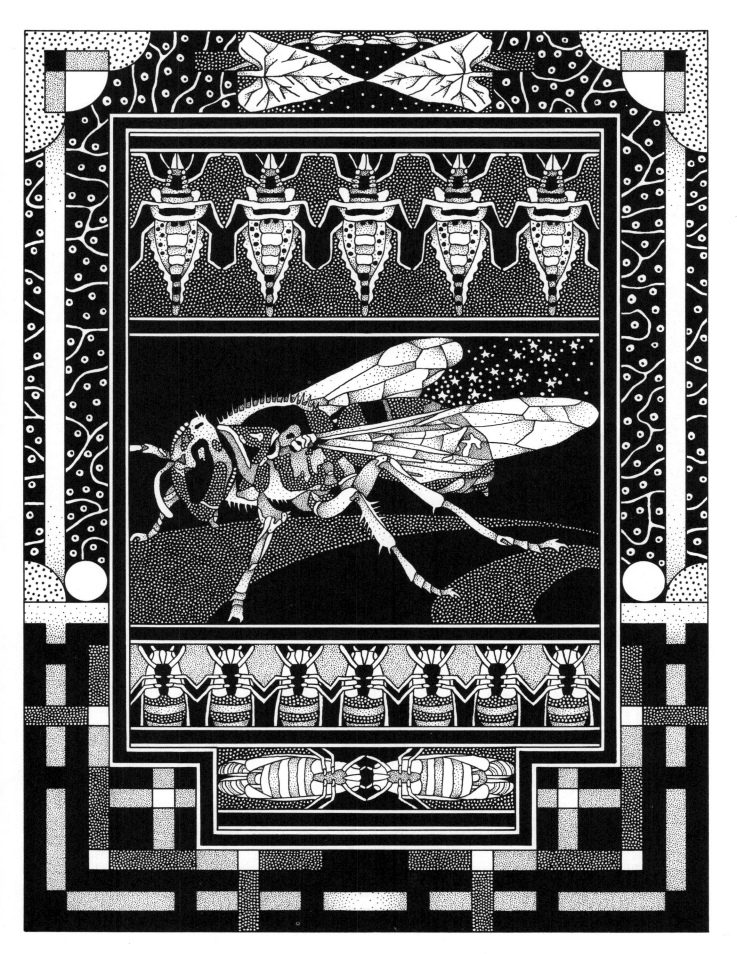

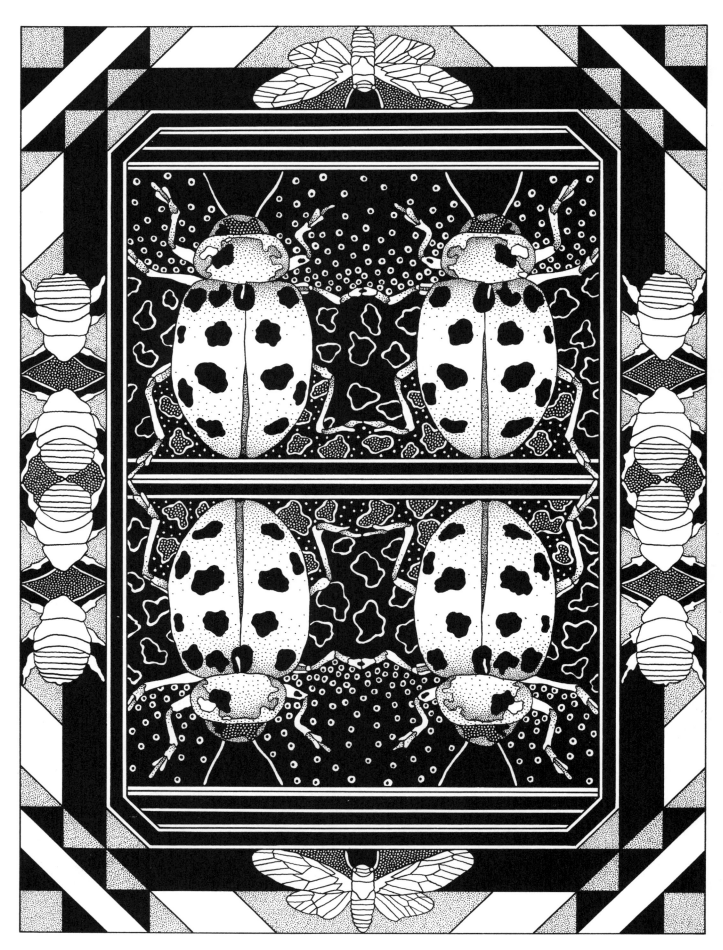

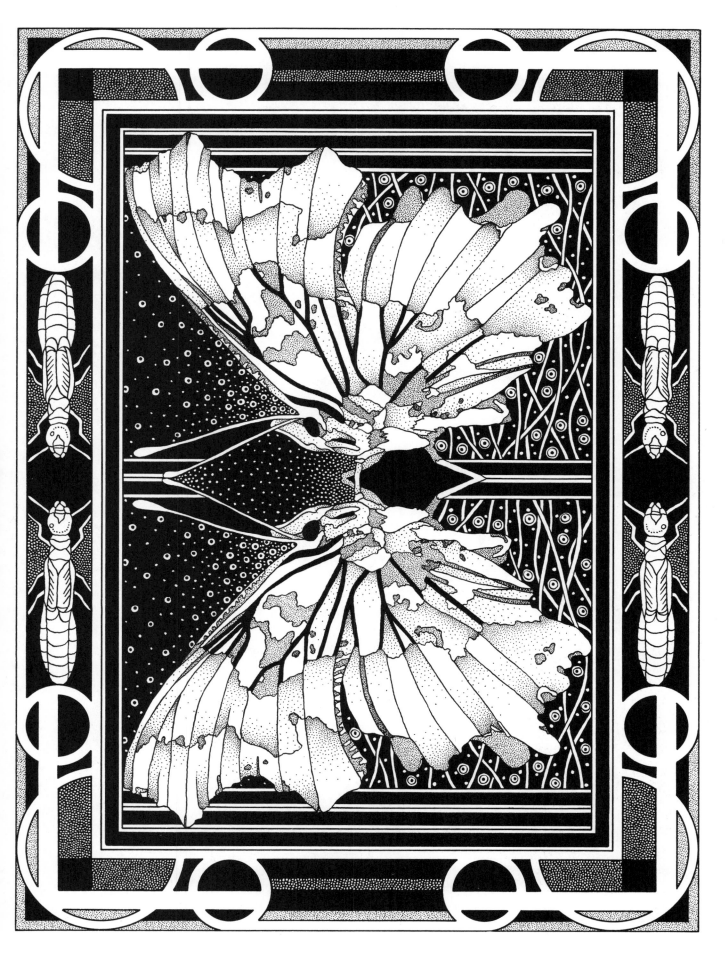

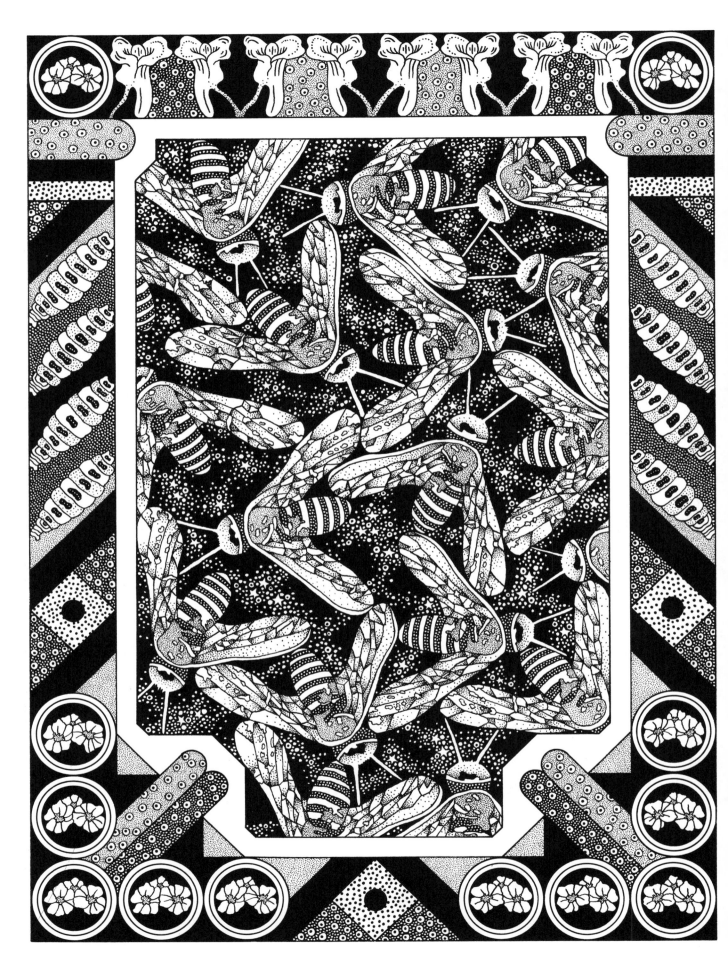

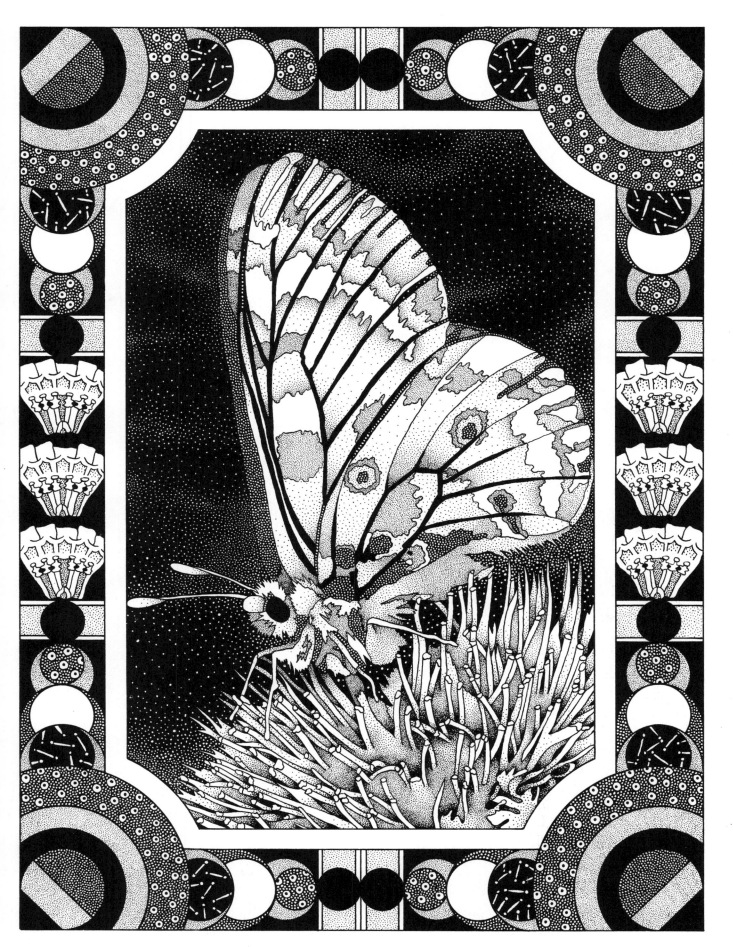

69

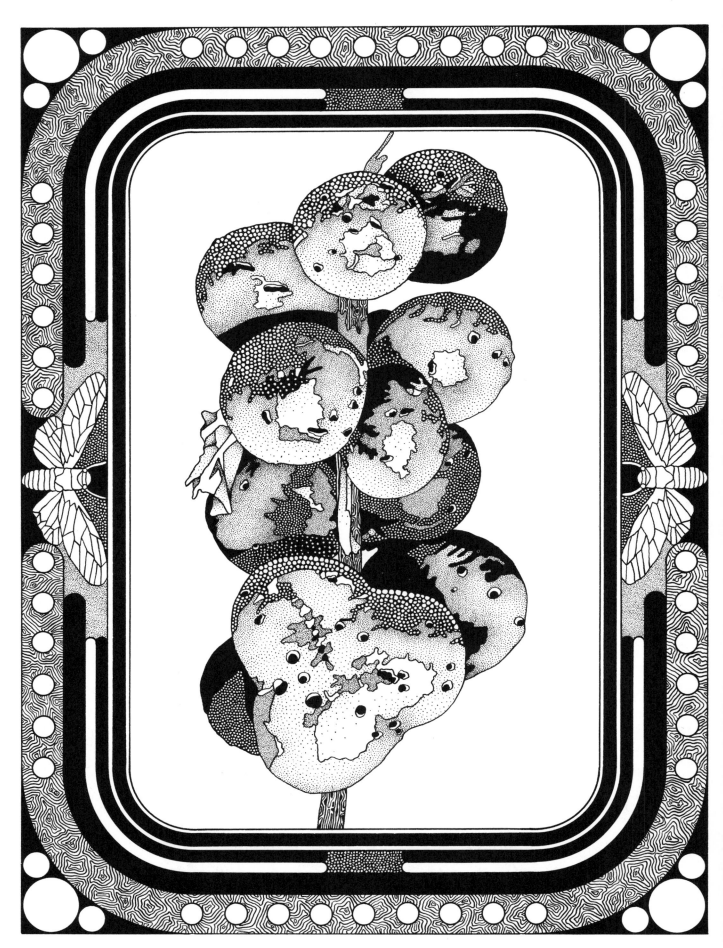

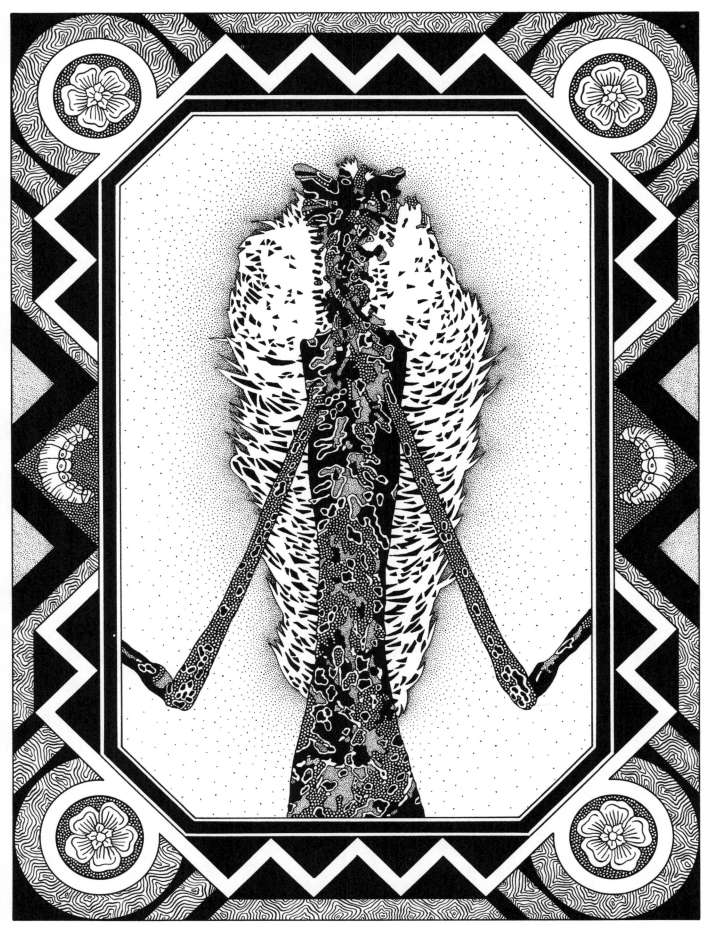

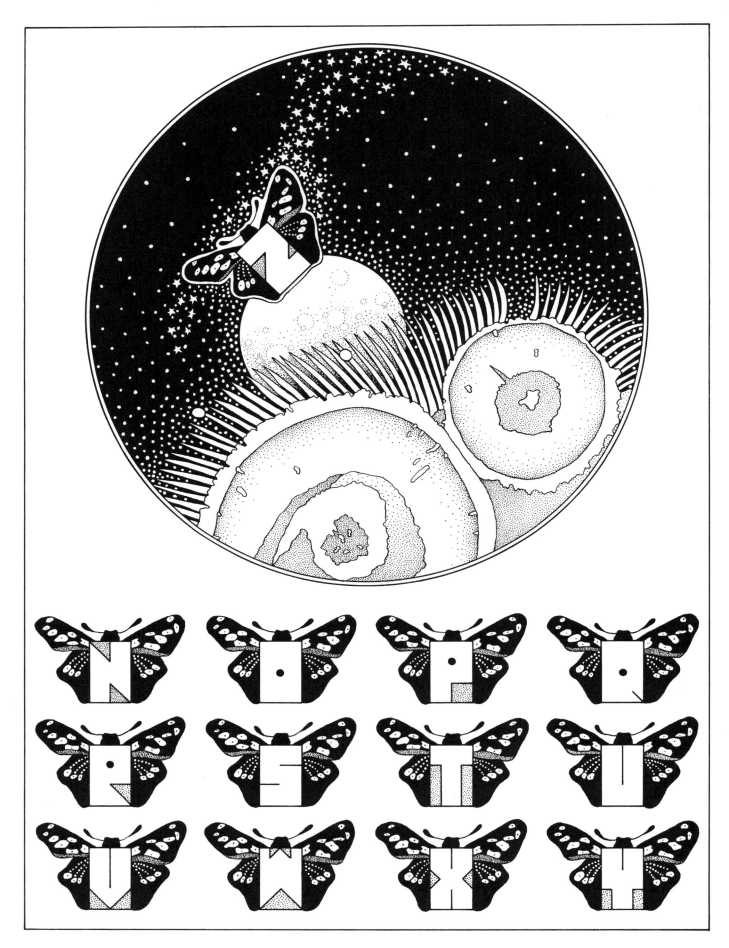